Engaging the Adolescent Mind

Through Visual Problem Solving

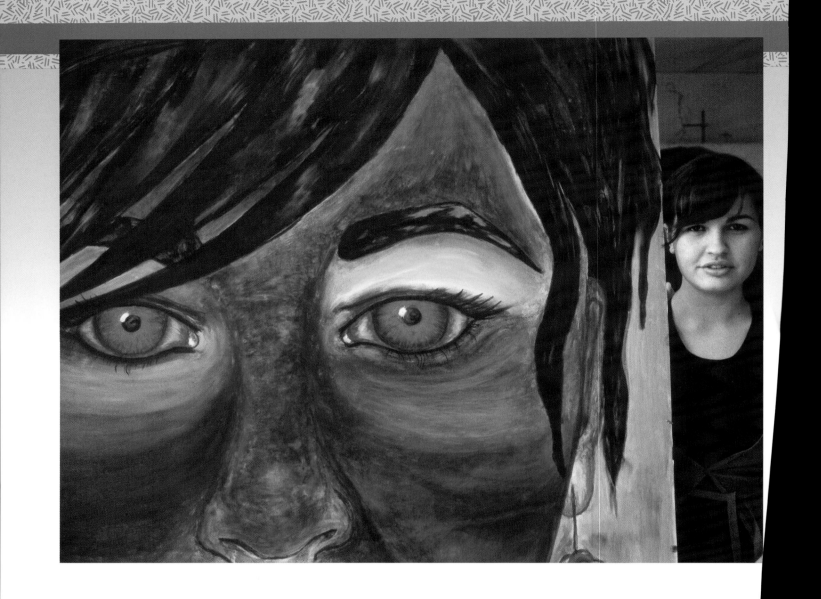

Engaging the Adolescent Mind

Through Visual Problem Solving

Ken Vieth

Davis Publications, Inc.
Worcester, Massachusetts

Publisher: Wyatt Wade
Managing Editor: David Coen
Production & Manufacturing Manager:
 Georgiana Rock
Editorial Assistance: Jillian Johnstone and
 Katherine Kane
Design: Janis Owens, Books By Design, Inc.

Photographs by Ken Vieth

Illustrations page 28 by Susan Christy-Pallo

Title page illustration: Siena Artuso with her 4' x 8' oil pastel self-portrait (detail).

Library of Congress Catalog Card Number:
2005921928

ISBN 10: 0-87192-694-6
ISBN 13: 978-0-87192-694-4

10 9 8 7 6 5 4 3 2

Printed in the United States of America

Acknowledgments and special thanks to:

All the hardworking students from
 Montgomery High School, Skillman, New
 Jersey
My publisher, Wyatt Wade, and my editor,
 David Coen, of Davis Publications
Dan Bush, for his ongoing support and his
 dedication in creating educational videos
 about many of the studios included in
 this book
Eldon Katter, editor of *SchoolArts* magazine,
 for his support of my work
The Geraldine R. Dodge Foundation, New
 Jersey
My family and friends, especially my wife,
 Joann, and my daughters, Kyla and Erin

Contents

13

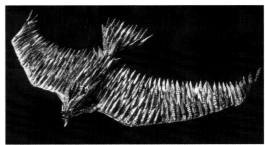

41

62

Chapter 4 Personalized Art History 72

88

Chapter 5 Providing Rich Diversity for Your Art Program 102

107

Conclusion 138

Introduction

This book is intended as a resource for art teachers seeking new and definitive ways to identify and solve thought-provoking visual problems. The two- and three-dimensional media projects developed here offer varying degrees of difficulty, from introductory level to those involving higher-order thinking skills such as synthesis, analysis, and reflection. I hope that this book, like its predecessor, *From Ordinary to Extraordinary: Art and Design Problem Solving* (Davis), will provide a jumping-off point for artist-teachers who want to foster creative expression and develop their own creative studio projects.

Engaging the adolescent mind can be both stimulating and challenging. My enthusiasm for teaching at the intersection of creative expression and higher-order thinking has given me many challenges and enormous personal satisfaction throughout my career as an artist and teacher. For students, art can and should be exciting as well as thought provoking. Each new school year I tell my students that they are truly taking the best course in the entire high school. They might look at me quizzically at first, but I go on to explain my conviction that the academic art program offers unlimited choices for creative thinking, problem solving, the development of technical skills, and personal expression. In short, the visual arts can offer tremendous opportunities for artistic and personal growth.

The Importance of Critique

As we know, the maturation process of adolescence is a life-changing experience. In the course of defining themselves, young people can become defensive, resistant, even confrontational. I have found that the most effective teachers are those who provide nonjudgmental critique on a daily basis. The benefit of daily critique lies in ensuring that students have no negative surprises when it comes to the final assessment of their achievement.

The process involves thoughtful communication as the teacher speaks directly and objectively about student work. This means focusing on the use of media, composition, and overall design. It means talking about how the viewer's eye moves through the student's work. Where does the eye stop? What areas flow or show movement? What aspects contribute to visual unity? I try to avoid personal judgments in order to motivate students to produce their best-quality work. Such daily critical feedback may be the single most important way to promote a high standard of achievement.

In addition to providing thoughtful, nonjudgmental critique, teachers need to provide a physically and emotionally safe environment for students to think and work. Students should be encouraged to take time to slow down and reflect on what they've learned. Their art-making environment should be inviting, supportive, and designed to meet their needs.

The Developing Brain and Cognitive Connections

Recent technological developments have increased our knowledge of how the human brain develops. Research now reveals that significant growth takes place in the

human brain during adolescence which was only recently thought to happen in the first three years of life.* In understanding this growth we can develop a greater awareness of the thinking skills and significant challenges faced by the students we teach. Further published research has proved "what every parent of a teenager knows: not only is the brain of the adolescent far from mature, but both gray and white matter undergo extensive structural changes well past puberty. . . . The best estimate for when the brain is truly mature is twenty-five."†

Elliot Eisner, a leading theorist on art education and aesthetics, has argued that we, as artist-teachers, need to develop cognitive flexibility to promote artistic growth in ourselves and our students. Cognitive flexibility utilizes all the brain functions without putting unnecessary limitations on the thinking and creative processes.‡

I believe the key for promoting achievement in studio art is in structuring visual problems that make cognitive connections between media, artistic skills, and personal expression. To do this, we must engage and exercise our own thought processes to allow for greater insight, productivity, reflective learning, and personal ways of thinking.

* "Mind Expansion: Inside the Teenage Mind," *Newsweek,* May 8, 2000.
† "What Makes Teens Tick?" *Time,* May 10, 2004.
‡ Elliot Eisner, *Cognition and Curriculum Reconsidered* (New York: Teachers College Press, 1994).

Over the years, I have been on a quest to increase my effectiveness as a teacher who can structure clear visual problems that are engaging to the adolescent learner. We all see the world in very different ways, and we allow the exterior world to influence and activate our internal thinking. We are motivated to artistic expression as we reflect on the world around us.

Creative thinking and teaching is all about being receptive to new ideas—the seeds from which original studio experiences can grow. A new idea will flourish as it is mulled over in the mind and eventually brought to fruition. At times, two or more ideas blend to produce an even more expressive, hybrid possibility.

Artist-teachers need thinking time, and for some, summer break can provide the time to regenerate. We can visit art museums and galleries, read art magazines, and visit other artists' studios. School vacations may also provide time for teachers to focus on their own creative work. During this regenerative time we can observe new uses of media, and how they influence style as well as make new connections in expressing visual ideas.

Developing the Visual Problem

As new ideas are developed to the point where we see their application for our students, thoughtful preparation and planning may begin. There are a few important factors that come together when creating a visual problem. In developing visual problems we need to:

- Create guidelines that point the student in a clear direction, and share the visionary possibilities with enthusiasm. This approach naturally leads to diverse and individual results.
- Pay attention to the details of each visual problem so that students are challenged, yet not frustrated by what is being asked of them. I find it best to work with an idea or technique that is just at or beyond the students' reach—one that is challenging yet not overwhelming.
- Share clearly developed and well-defined objectives for the visual problem.
- Show enthusiastic commitment to the process, and be a part of the process, via either frequent critique or actual participation. Take the time to share in the challenges students face.
- Offer thinking/reflection time as part of the creative process. This, of course, need not be limited to the actual time in the art room.
- Develop not only clear objectives, but also a clear reflective evaluation and/or rubric.

Throughout the creative process, stress the "conversation" the artist has with his or her materials. Introduce the concept of the artist in dialogue with both ideas and media. Share with students your understanding of the intuitive nature of art.

Your presentation of the visual problem is critical to the success of the process. Choose words that positively open doors to possibilities, rather than imposing limitations. Students need to feel they are being invited into a new area of thinking and expression.

Recently, in discussing the concept of visual problem solving with a curriculum administrator, I was asked, "What would make an elegant visual problem?" Over time, the notion has continued to intrigue me. I now realize that the most engaging visual problems involve a clearly defined set of criteria whose application can lead to a fully successful studio experience. At the most basic level, the process involves four things:

1. A creative idea that stimulates both teacher and student
2. A defined set of objectives that is well planned and organized yet allows for multiple outcomes
3. A technical challenge that requires an effort of physical skill and allows for individual personal expression
4. An opportunity for students to reflect on what they have learned through the process

An elegant visual problem may be charted as a complete circle, starting from the original idea, to defining the project's objectives, to the processes of creative thinking and personal expression, and finally the process of reflective thinking

(see the chart below). The act of verbal reflection during class critique or in student reflective writing may lead to further refinement of the original idea. In any event, defining the structure and scope of the experience is critical, as are the need for both teachers and students to be flexible, to take risks while avoiding limitations, to aim for surprise, and to work hard to achieve excellence.

The elegant visual problem is presented with clarity, enthusiasm, visual references, and organized materials that are brought together to make the studio process go

smoothly. It should be noted that visual problems may vary in depth and breadth, depending on students' experience. For beginning art students, the problem might be weighted more toward increasing skill levels so that, ultimately, their knowledge of tools, techniques, and materials can be applied to greater personal expression. In the end, whether designed for beginning, intermediate, or advanced learners, visual problems need to be well-structured concepts that support and challenge our students' needs, interests, and varied abilities.

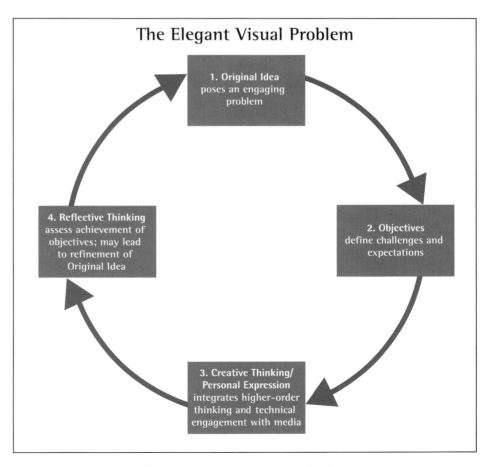

The Elegant Visual Problem

1. **Original Idea** poses an engaging problem

2. **Objectives** define challenges and expectations

3. **Creative Thinking/ Personal Expression** integrates higher-order thinking and technical engagement with media

4. **Reflective Thinking** assess achievement of objectives; may lead to refinement of Original Idea

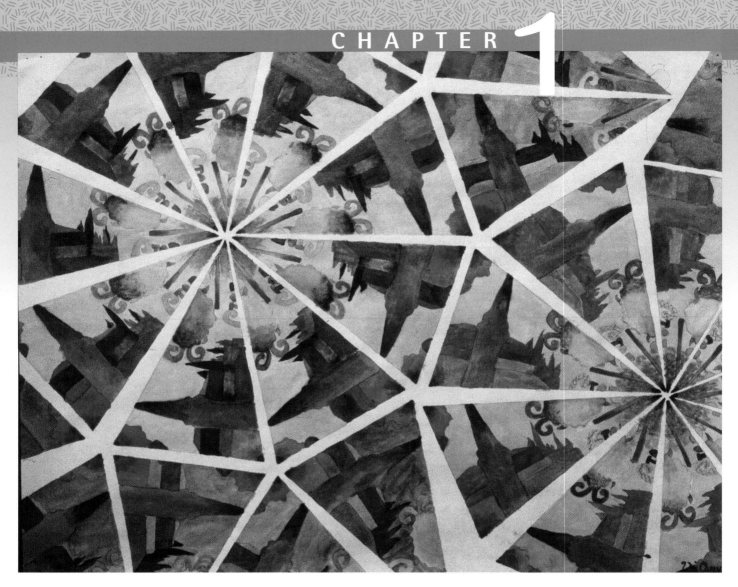

Wei Ouyang
Watercolor, 18" x 24" (45.7 x 61 cm).

Design

I am a strong believer in the value of promoting both visual awareness and knowledge about the world we live in, especially regarding the ways artists and designers have influenced all of our lives. As students reflect on the concept of the built environment, they begin to understand that everything in our world, outside of nature, has been designed by someone. Over time, those designs that endure, that best marry form and function, result from designers' ability to respect and apply the elements and principles of design to their work.

The principles—unity, emphasis, balance, etc.—that help artists organize the elements of design—line, shape, and form, etc.—in their compositions are interdependent yet can be applied in many combinations. Successful design gives visual order to the composition and the idea or subject being developed. This chapter will describe projects that might be viewed as building blocks for developing in students a thoughtful visual design sense.

Kitchen Utensil Design

Inspiration

This project, which begins with a series of planned homework drawings, evolved out of my efforts to encourage beginning art students to see that any form can be used to create an unusual design or pattern. The subject-form could easily come from nature, though in this case a manufactured object was selected.

Visual Problem

How can a simple everyday object, such as a kitchen utensil, be used to create an unusual or visually appealing pattern?

Materials

▶ sketchbooks (11" x 14" minimum)
▶ pencils, felt-tip markers
▶ 4" x 6" oak tag for stencils
▶ X-Acto knives, scissors
▶ 18" x 24" newsprint and white vellum

Time

Eight 45-minute periods: 1 for review of homework assignments and to introduce classroom studio, 2 to draw and cut the oak tag stencil and experiment on 18" x 24" newsprint, 2 to produce the light pencil drawing on white vellum, and 3 to develop the image in color using felt-tip markers

Student Choices

• media for homework
• subject
• orientation of object-form and direction of pattern
• color

Preactivity

Students should select a single object found in the kitchen, such as an electric mixer, teapot, ice-cream scoop, wire whisk, can opener, or potato peeler, and draw it in five varied ways in their sketchbook:

1-1 Julie Baker
This design features a pizza cutter repeated on the diagonal.
Felt-tip markers, 18" x 24" (45.7 x 61 cm).

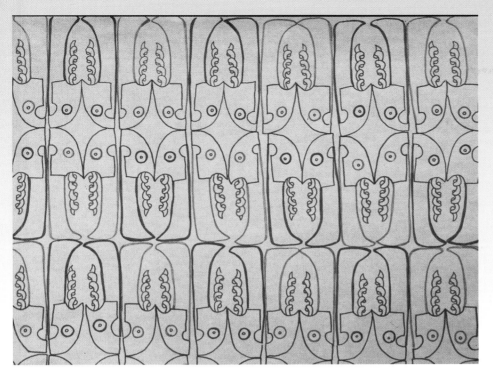

1-2 Marni Kleinfield-Hayes
A repeated corkscrew image creates both positive and negative shapes.
Felt-tip markers, 18" x 24" (45.7 x 61 cm).

1. in contour line or weighted line
2. in value study (rich blacks through shades of gray)
3. in the color and media of the student's choice
4. in black and white or color, emphasizing the texture of the object (smooth, rough, reflective, etc.), and
5. repeating the shape of the object in pencil as a line drawing to create a pattern that fills a large sheet of paper

This homework can be done over consecutive days or weeks if desired. Group critiquing happens after each individual drawing is done. The fifth image is intended to serve as a rough draft for the classroom project.

As an art history reference, teachers may want to share the work of M. C. Escher (Dutch graphic artist, 1898–1972), whose work offers examples of rhythmic repetition of like shapes found in nature and in art.

Process

As students bring in their sketchbooks and share their last image in a group critique, point out which designs maintain the most interest when developed as a pattern. This allows students to see how they have done in relation to their peers and to make decisions about how they will proceed. Be sure to note how any object can be oriented right-side up or upside down and repeated across the page from side to side, from top to bottom, or at a diagonal to create a pattern.

The classwork component begins as students trace or redraw their chosen subject onto a sheet of oak tag (4" x 6") from which they can create a stencil. The stencil should be used to experiment on newsprint with repeating their image to create an identifiable pattern that completely fills the paper. Students are encouraged to carefully consider the negative space created as they develop their pattern. A final image can be developed in light pencil on a sheet of 18" x 24" white vellum.

When this drawing is complete, students can make decisions on the color range they want to employ in developing their image with felt-tip markers. To ensure that the image evolves as a whole composition, and to avoid the tedium of the need to complete an entire object before moving on to the next object in the pattern, I suggest that

1–3 Erin Santye
The end view of a teapot spout inspired this strong design.
Felt-tip markers, 18" x 24" (45.7 x 61 cm).

each color used be applied all at once as it repeats throughout the composition in line or shape.

Encourage students to take the time to view how others in the class are completing their images and how their choices of color work to achieve color unity. Finally, inform students that successful design is by nature clean and precise, so craftsmanship is extremely important. It is important to avoid making dark graphite lines on the white paper or smearing the water-based markers.

Evaluation

Ask students: Can the viewer easily see the repetition in your design? What elements create visual unity? How could this type of imagery be used in another way? Do you see any potential for use of the pattern in product design or marketing?

Results and Observations

Students benefited from the homework component, as it allowed them to consider and prepare for the design challenge of the classroom experience. They easily made the transition from drawing a single object to repeating it in the form of a pattern, and they seemed to enjoy the freedom of expression the project's composition and color choices allowed for.

Conclusion

This experience offered beginning art students a basic-level design understanding and the experience of producing bold and varied designs from simple kitchen utensils. Some students commented that the finished work looked like wallpaper or wrapping paper, while others saw the potential for using pattern in product advertising design.

Foreign Currency: From Observation to Exploration of Pattern

1-4 Isolated view from Russian currency.

1-5 Wei Ouyang
The urban architectural view, isolated as a bold triangular shape, offers a promising jumping-off point for the design shown in Figure 1-9.
Watercolor, 4" x 6" (10.2 x 15.2 cm).

Inspiration
World travel in recent decades has become ever more convenient for both business and pleasure. With a little effort, one can acquire a wide range of varied currencies. An appreciation of their visual differences and variations of imagery can be used as a jumping-off point for greater understanding of line, color, and shape as well as how repeated shapes can produce pattern.

Visual Problem
Direct students to produce an enlarged image based on subject matter chosen from an isolated section of foreign money. This image will be first developed observationally in color and then redrawn in mixed color to create a repeated pattern.

Materials
▶ foam-core board for mounting currency
▶ a variety of foreign currency
▶ tracing paper, 8½" x 11"
▶ oak tag
▶ hard-pressed 100 lb. paper, 18" x 24"
▶ HB pencils, colored pencils, watercolors

Time
Twenty-two 45-minute periods: 1 to introduce the two-part project, 9 for Part 1 observational drawing, 12 for Part 2 pattern development

Student Choices
• currency
• shape to be enlarged
• media
• pattern to be developed

Process
Part 1
Students begin by selecting a paper currency they find visually engaging and mounting it onto a small sheet of foam core using masking tape. A sheet of tracing paper may be used to select an area from that currency. Students should choose and draw a shape over the area that they wish to enlarge. Next, that overall shape is transferred to an opaque white paper, cut out, and overlapped on the selected money, creating a window. This limits the focus to the exact area on which the student will concentrate.

Students will then observe and represent the varied forms, colors, and textures of the selected section of currency. The enlargement of their chosen area will be twice the size of the original shape. To develop this first image, students will use a combination of colored pencil and watercolor.

Evaluation
Part 1
Ask students: How well is the selected image replicated in terms of color, line, shape, texture, and scale enlargement?

1-6 Isolated view from Korean currency.

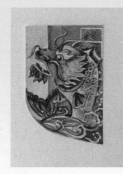

1-7 Dianna Wojcik
This first-image rendering of the currency area achieved great accuracy.
Watercolor, 4⅜" x 2¹¹⁄₁₆" (11.1 x 7 cm).

Results and Observations
Part 1

Students chose to work with foreign money from a number of different countries, including Italy, France, Finland, Hong Kong, Russia, Estonia, China, Germany, and South Africa. The observational aspect worked well as the students, slowly at first, began to experiment with mixing color and replicating the color to match the currency they had selected. The combined use of watercolors and colored pencils worked extremely well as most students began with a wash of color before using colored pencils for the fine detail.

Process
Part 2

Students will use their identified shape to develop a repeated pattern. They begin by tracing the contour and then transferring it to a sheet of oak tag. The oak tag shape is used as a template on newsprint paper (18" x 24"), as the shape is repeatedly traced to develop their design. Close attention is paid to the use of negative space as well as the overall direction that the repeated shape creates. Once this preliminary design is complete and students are satisfied with their composition, they redraw this design onto a sheet of white vellum paper (18" x 24"). This is done in preparation for the final image to be developed in mixed color.

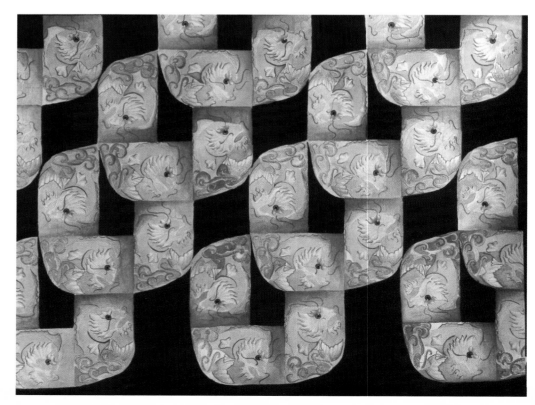

1-8 Dianna Wojcik
The interlocking forms of this second image keep the viewer's eye moving. Watercolor and black acrylic paint, 18" x 24" (45.7 x 61 cm).

Students continue the process using pencil to trace the most important compositional elements found within their enlarged selection of currency. This will include all of the boldest of lines and forms yet none of the fine details. This information is then repeated in each part of their newly established pattern on the final white vellum paper.

When this light pencil drawing is complete, students can then begin the process of developing the image in a new color range, changing the media density for overall visual emphasis. The overall idea is to have students creatively explore the image in a new way, seeing the observational drawing created in Part 1 as a jumping-off point for their self-expression in developing the pattern. They will choose any media or mixed media in which to develop their pattern—options might include felt-tip markers, pastels, watercolors, colored pencils, or a combination of media.

Changes such as line variation, repeating mixed color, and changing the density of how media is applied are encouraged. Students are told that the overall pattern they develop will look similar to a swatch of fabric or wallpaper, where the viewer would be looking at only a section of a much larger surface.

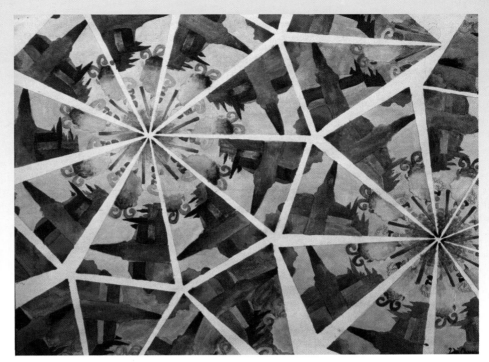

1–9 Wei Ouyang
The repeated watercolor image creates the illusion that it goes on forever. Watercolor, 18" x 24" (45.7 x 61 cm).

Evaluation
Part 2
Ask students: How is your pattern established? Do your images reflect changes in color density? Is the overall image visually engaging? How so? To what degree is personal expression apparent?

Results and Observations
Part 2
This portion of the studio encouraged greater self-expression as students developed personalized patterns and new color schemes. The emphasis on mixing color, repeated color, and change in color density added to the overall success of this project. This project might easily have been modified to focus on other aspects of color theory such as the use of complementary, split complementary, or analogous color.

Conclusion
The initial observational drawing exercise encouraged practice in realistic drawing techniques before students applied their creativity and personal expression to developing the enlarged pattern in mixed color. The students' individualized manipulation of varied currency from different countries led to a stunning range of results in the finished works.

Letter Design

Inspiration

Typography, or the style, arrangement, and appearance of typeset material, is a fascinating element of graphic design. Anyone who has discovered the many options for font changes that come with today's word processing programs has enjoyed the freedom of choosing a typeface for written documents. I have found that giving students the opportunity to design their own letter form that is unique to themselves can both inspire creativity and increase visual awareness of these forms. Through manipulation and abstraction of letter forms, students can maximize their visual expression and explore the potential in creating a repeated design.

Another motivation was to have students see the evolution of an idea as a process. For the lettering exercise to evolve into a creative design experience the project needs to be clearly structured to encourage visual transformation. A further goal is to have students see how a two-dimensional idea can be further transformed into a relief.

Materials

- 12" x 12" white vellum drawing paper
- fine-line markers
- colored pencils
- X-Acto knives, T-squares
- black construction paper for mounting
- rubber cement or glue stick

Visual Problem

Using their name as the subject to be developed, students will create a new letter form, or font. This new font will evolve into a color relief design based on the student's name.

Time

Eleven 45-minute periods: 1 to introduce the lesson, 8 to develop the repeated squares and add color to the five deemed most successful, 2 to create and finalize the relief

Student Choices

- name
- media
- color

Process

Students begin by making experimental sketches for the new font using the letters of their first name, last name, or first initial and last name as the subject. The initial ideas are first developed in a

1–10 Jenifer Chen
Students developed a full page of ideas before choosing five they would finish in color. Felt-tip marker and colored pencil, 18" x 24" (45.7 x 61 cm).

sketchbook or on inexpensive paper. After brainstorming possibilities, students decide which of the experimental fonts they want to develop on a 12" x 12" sheet of white vellum paper.

The paper is divided into squares using a T-square. The students are offered two sizes of squares in which to work. They can merely trace the sides of the T-square, which results in one-and-a-half-inch squares, or they can measure a series of two-inch squares. Students use pencil to

1-11 Jenifer Chen
Color contrasts and the relief created by cutting and mounting the letter forms added to the success of this project.
Colored pencil, 12" x 12" (30.5 x 30.5 cm).

draw their name in each square, using the font they chose from their initial ideas, to consider both the positive and negative space. Once this is complete the work continues as the letter form image is altered and changed as students move from one square to another. The aim is for students to thoroughly investigate the structure of the letter form. They are to consider both the positive and negative space as the letter form is manipulated.

When the page is complete, students will then choose five or six of their best design squares to be further developed in color on the

same sheet. Students can use colored pencils, felt-tip markers, or a combination of both. Encourage students to personalize their color by mixing.

As the students view this developmental sheet of images they select one square they feel is the most successful in terms of structure and color. This will be enlarged onto a 12" x 12" sheet of white vellum. Students will continue to develop color thoughtfully, yet are free to combine the design from one square with the color scheme from another.

The final process in the project is the creation of a relief to be

mounted on black construction paper. X-Acto knives are used to cut a variety of the shapes found in the students letter-form design. These shapes are curved and reattached, using rubber cement or glue stick, to the black background.

Evaluation
Ask students: Is the design still readable? Is the color thoughtfully developed? Does the color help to create visual unity? How do the relief levels enhance or create the quality of rhythm seen in the overall image?

1-12 Pana Stamos
The bold, clean style of this design creates a unique letter form. Colored pencil, 12" x 12" (30.5 x 30.5 cm).

1-13 Hee Won Shin
This image shows a clearly balanced design created on varied levels. Colored pencil, 12" x 12" (30.5 x 30.5 cm).

Results and Observations

The real challenge for students of this project was not development of a font that they personally liked but the evolution of that font on the 12" x 12" sheet of vellum. The designing and redesigning of a letter form into fifty to sixty varied images proved to be a real reach for high school students, yet this process produced positive results because students were willing to reach beyond their first ideas. This exercise helped students to explore and develop an idea to its fullest potential.

Working in a square format increases the design challenge, as written names naturally fit in a rectangular space, not a square one. The square encouraged further thinking in regard to design and use of positive and negative space.

Letter form may be used in many ways to develop design images. The most important aspect of this project is pushing the investigation of the letter form to its fullest extent. One key to student success is to offer frequent critique and positive motivation as students work through the processes.

The resulting final images were personal due to students' use of their own name, and visually striking due to the color images developed on a relief surface.

Conclusion

This studio experience succeeded in combining creative thinking and development of a personalized subject. This process continuously engaged the students to think and to invest a high level of commitment to the process.

Letter-Form Design: Three- and Four-Point Perspective

Inspiration
This studio process began with a design based on rectangular interlocking forms that applied the rules of three-point-perspective drawing. As the students worked their way through this process, I decided to challenge them to create a personal artistic statement utilizing the same perspective rules. Encouraged by their initial work, I encouraged students to use the letter form of their full name connected in creative ways. They would apply the rules of three- and four-point-perspective drawing to creating a personalized design.

Visual Problem
Applying the rules of three- or four-point-perspective drawing, students will develop a unified image using both their first and last names as the subject. The letter form can be interlocked, overlapped, or in some way creatively interconnected. This image will be fully developed by blending or mixing color to create a highly personalized image.

1-14 Mike Cheng
All lines are directed to one of the three vanishing points.
Colored pencil, 12" x 18" (30.5 x 45.7 cm).

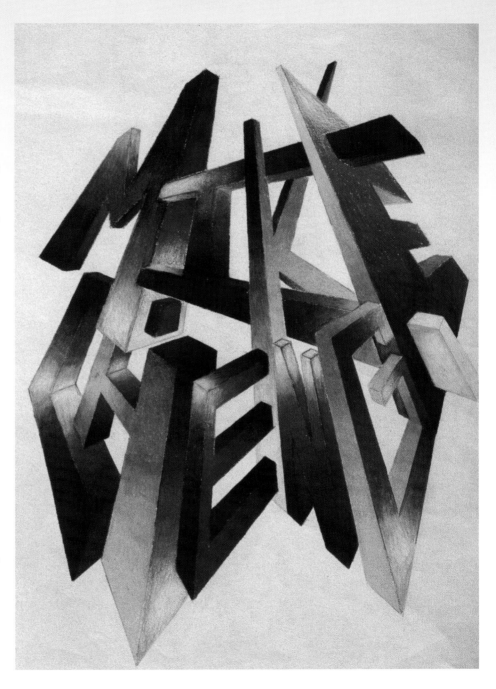

1-15 Lauren Jones
The three-point-perspective drawing explores interlocking rectangular forms.
Felt-tip marker, 12" x 18" (30.5 x 45.7 cm).

Time

Fifteen 45-minute periods: 4 for interlocking rectangles drawing, 5 for name image design, 6 for color development of final image

Student Choices

- use of three or four vanishing points
- size of final paper
- choice of color for developing final image

Start-up Activity

To prepare students to create a drawing of interlocking rectangles using three vanishing points, review the basic information regarding the correct use of vanishing points in two- and three-point-perspective drawing. The importance of utilizing vanishing points is naturally to create consistent angles in the relationship of the drawn figure to the ground. In two-point perspective, each of two vanishing points is placed on the horizon line on opposite sides of the paper. Any given horizontal angle is then grounded to these two points. In three-point perspective, a third point may be placed at the top of the page. All vertical angles should then line up to that point. Use of the third vanishing point will visually exaggerate the form of any structure.

To begin the first rectangle, students are instructed to draw a vertical line that is directed to the top vanishing point. This will be considered the closest edge of the rectangle to the viewer. Students will direct two lines from this line to one vanishing point on the horizon line, choosing the right or the left point. The last line of this shape is directed again to the vertical point at the top of the paper, thus completing the basic rectangular shape. The result is a linear yet skewed-looking rectangle.

Next, students should create a smaller rectangle inside the first, following the same vanishing points. This new interior shape will be developed as a visual "hole" through the first rectangular shape. The illusion of depth is created by using shorter lines directed from this rectangular shape to the opposite horizontal vanishing point. The student decides the depth of each rectangular form.

This process is done very lightly in pencil so that part of the first rectangular shape can be erased to permit the second rectangle to be interlocked. Students begin the second rectangle by drawing the closest line to the rectangle (considered the "closest edge") and repeating the preceding steps. This process is continued until six or seven interlocking rectangles are developed. When the rectangles are complete, fine-line markers may be used to outline the finished images in order to clarify each form.

Students should be reminded that every line drawn must be applied to one of the three vanishing points. The overall size of each rectangular form is decided by each student. The image may appear as a series of interconnected trapezoids, yet in three-dimensional reality they remain interconnected rectangles.

Process

Instruct students in the use of vanishing points when creating each letter of their name. Every line that is drawn is directed to one of the vanishing points. The fourth point is located along the bottom of the paper and its location can be selected as the need arises. All letters will line up to the two on the horizon line and the one at the top of the page. Letters based on characters such as W, M, and X require a fourth vanishing point, the placement of which students can decide as they work through the placement of each letter in their name.

For best results, encourage students to follow these four basic steps in developing their name designs:

1. Create thumbnail sketches using simple lines on 8½" x 11" or 12" x 18" newsprint paper. This is done to see roughly how each letter will be directed to one of the three or four vanishing points. This can also help in the overall composition of letters in the first and last name.
2. Add width to each individual letter using the same vanishing points. The student's name must be readable.
3. Observing that the thickness of each letter results from the use of the two horizontal vanishing points, students should identify on each letter a closest edge in which every line to the left of that closest edge lines up to the left or right vanishing point.

1–16 Lila Symons
The letter forms of this bold, easily readable image have a satisfying visual depth.
Colored pencil, 12" x 18" (30.5 x 45.7 cm).

Verticals go to the top vanishing point, and a fourth point, for those letters requiring it, may be placed at the bottom of the page.

It is important for teachers to check student work to make sure that each line being created is directed to one of the three or four vanishing points, because at first glance the lines may appear to be correctly drawn when in fact they are not. Remind students that their created design should be fully legible.

4. To create a fully unified design, students are encouraged to overlap, interlock, and/or have some letters appearing to pierce through others to make a visual connection. The aim, again, is a final arrangement of forms that creates a compelling yet readable design.

When the rough draft on

1-17 Melissa Chung
The illusion of interlocking forms creates a rich complexity.
Colored pencil, 12" x 18" (30.5 x 45.7 cm).

newspaper is completed, give the students a 12" x 18" sheet of white vellum (80 lb.) paper for their final draft. A light line drawing is desirable so that in the image's final color development the graphite will not mix into the chosen media. Students should select either colored pencils or watercolors to develop personalized color. Students should mix and blend their chosen media and be cautioned to keep the negative space totally clean.

Evaluation

Ask students: Is your name readable? How well is your letter form design interconnected? How did you decide on color or use of media? Does your color selection show visual continuity?

Results and Observations

The start-up activity of drawing interlocking shapes provided students with a useful review of the rules of perspective and the basic principles behind the use of vanishing points. Those students who followed the subsequent four basic steps in the letter form design process tended to have better unified compositions and fewer technical problems.

In the first two classes, students worked hard to problem solve the linear direction and overall design of their names. During this time the teacher can act as a facilitator to help with the most difficult letters when a student feels stuck. When the design was completed the focus moved on to decision making over use of media and mixing of color. The process went very smoothly.

Though some students chose larger paper, 18" x 24" white vellum, most worked on the 12" x 18" size. Most chose to work in colored pencil.

Conclusion

As artists and teachers, we need to engage our students' visionary imaginations, support their creativity by promoting increased skills, and further their personal artistic expression. This studio project has an architectural and structural feel as well as personalized content. Tackling this visual problem produced excellent student results in which students could see the limitless possibilities for structuring letter forms in visually engaging ways.

Collaborative Accordion Books

Inspiration

Museum stores always attract my attention. They tend to offer varied, creatively designed objects that create interest and sometimes inspire ideas for exciting student work. In a recent visit to two art museum stores, I purchased a few cut paper folding cards. Some were realist in subject, while others were selected for their pure design. Like pop-up books, these images held an element of surprise and offered the viewer ideas about form and space in a small area.

I knew that my students could appreciate the qualities of the ideas, craftsmanship, and overall simple designs found in these cards. It occurred to me that the design approach used in the cards might be applied to the creation of accordion books reflecting simple shapes. The books could be constructed in a collaborative way, either in pure abstracted design or in more realist subject matters. I was intrigued by the idea of creating an art book that used only the language of art.

Materials
▶ newsprint
▶ 80–100 lb. white vellum, 12" x 18", cut to 6" x 24"
▶ X-Acto knives
▶ tracing paper
▶ a variety of metallic paper—highly reflective with self-adhesive backing
▶ rubber cement or white glue

Visual Problem
Students will utilize a simple cut paper technique to develop two foldout designs into accordion books. One image will use only designed or geometric shapes and the other organic shapes or a subject found in nature.

Time
Ten 45-minute periods: 1 to introduce and begin preliminary drawings in sketchbooks, 8 to develop two folding images, 1 to construct and bind each book

Student Choices
• subject and their style of development
• kind of paper used

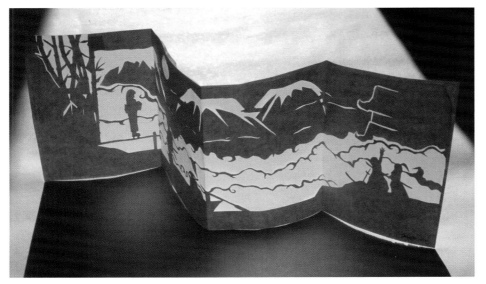

1-18 Joseph Liu
Tracing paper offers support to the amount of negative space created.
White vellum and tracing paper, 6" x 24" (15.2 x 61 cm).

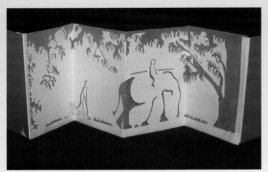

1-19 Catherine Singley
This accordion book offers a storytelling quality in the artist's choice of subject. White vellum and tracing paper, 6" x 24" (15.2 x 61 cm).

Process

Begin by showing students examples of foldout cards and pop-up books. Help students to analyze and understand how really complicated images can be created through folding and cutting.

Students can begin the process by choosing the kind of designed form or geometric shapes or organic shapes they want to develop. Long strips of newsprint (6" x 18"), scissors, and X-Acto knives are provided for students to work out rough ideas. The chosen form should be consistently developed throughout their individual section: If a circle is to be developed into their cut design, then it should be the main focus in their folded section.

After students have resolved their basic ideas, they can move on to use of the white vellum (6" x 24"). They choose the number of folds and the size of the folded areas. I repeatedly stress to students the importance of quality of craftsmanship. Measuring, cutting, and folding must be done cleanly. All light pencil lines need to be erased. Each section must be free of all marks before the final presentation is glued together.

The geometric or designed subject page included gold or silver metallic Mylar paper. This paper was selectively used to enhance the overall visual unity of the page. In the organic page the paper stayed completely white, emphasizing the use of shape and negative space. Composition and visual unity are stressed throughout this process.

Evaluation

Ask students: Does your work create an element of surprise as the viewer sees your individual section? Is there an understandable relationship in each of your folded panels? Is your page well crafted?

Results and Observations

Careful attention to craftsmanship added to the overall success of this project. Some students chose to use tracing paper as a translucent aspect on their white organic subjects.

Asking for two completed pages per student (one in organic shapes, one in geometric shapes) offered diversity and challenge to the beginning-level art students who undertook this assignment.

The covers for the accordion books were constructed by using two sheets of matt board, 4½" x 6". Rubber cement or white glue can be used to join the pages together as well as to adhere them to the front and back covers. A length of five to eight pages worked best as a complete book.

Conclusion

This project's combination of geometric designs found in designed forms and organic forms found in nature worked well to encourage diversity in thinking and expression. The simplicity of materials focused the student and the viewer on the overall design of each page and contributed to the visual unity of each accordion book. The final exhibition of completed books offered viewers an intriguing way of seeing books in an artistic context.

1-20 Holly Clare
Bold and varied tree forms show a balance of positive and negative space.
White vellum, 6" x 24" (15.2 x 61 cm).

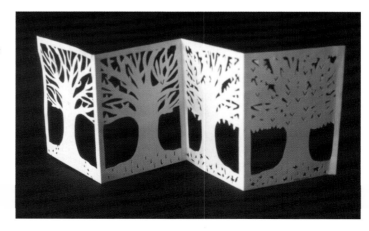

Structural Connections: Architecture and Sculptural Books

Inspiration

This project originated in my reflection on the work of American architects Frank Lloyd Wright and Frank Gehry, both of whom designed Guggenheim Museums—Wright the New York and Gehry the Bilbao, Spain. Both museums are notable architectural structures for their flowing organic forms, which invite visitors to enter the museums' interiors in the same way that an appealing book design can create in readers a desire to read the text within.

This thinking resulted in asking the questions What makes a visually inviting book or piece of architecture? Might it be possible for students to create three-dimensional sculptural books, exploring the relationship of exterior to interior?

Both books and architecture offer us opportunities to have rich experiences. Memorable books, like memorable architecture, are enlightening and inspiring. Celebrating the words of notable people in the arts was the inspiration for this lesson. Students selected an artist's quotation and then, based on those words, they created their own interpretive structures.

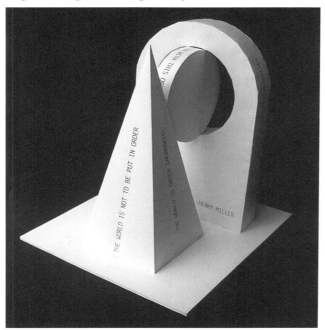

1–21 Andrew Bolen
Three striking single forms come together to offer visual power to the words of author Henry Miller. White vellum, 18" x 13" x 13" (20.3 x 33 x 33 cm).

Materials
- newsprint
- pencils
- 100 lb. white vellum paper
- scissors and X-Acto knives
- white glue and rubber cement
- watercolors, colored pencils, graphic pencils

Visual Problem

Students will create a three-dimensional sculptural book celebrating the influence of twentieth-century architecture and the words of a notable person who influenced the arts. They will understand how words can inspire form as they create a relationship of text to form.

Time

Fourteen 45-minute periods: 1 to introduce studio project, 12 to develop architectural book, 1 for evaluation

Student Choices
- artist's quote
- media
- size of structure

Start-up

Introduce students to images of contemporary architecture, specifically the Guggenheim museums in New York and Spain. Share comparisons of their sculptural qualities, noting how the buildings' forms relate to their function. Inside and

1-22 Xun Li
The tracing paper added to this asymmetrically balanced sculpture offers solidarity to its graceful form. White vellum, 7" x 18" x 9" (17.8 x 45.7 x 22.9 cm).

outside, both offer the viewer unique visual experiences.

Ask students to reflect on what visual qualities make an environment or a book desirable or inviting. As students note connections between architecture and books, they may observe that both have the potential to be visually engaging from both the inside and the outside. Books can have striking cover images that invite the viewer to enter and read the text. Books also offer, on a smaller scale, the opportunity to visit the interior space via the perception of words and images. A book's cover, layout, and overall design also invite "reading" on an aesthetic level.

Architecture also has readable and understandable formats. We look at spatial relationship of the form of the structure. Architecture by its thoughtful relationship to

form and material can also invite the viewer to want to experience the three-dimensional space within a structure.

Process

As inspiration for their architectural book, and to add variety and meaning to their form, students were encouraged to select from a set of quotations by notable individuals in the arts. Choices offered to students included verses from poet Robert Frost's "The Road Not Taken," singer/songwriter John Lennon's "Imagine," writer Henry Miller ("The world is not to be put in order; the world is order, incarnate. It is for us to harmonize with this order"), painter Georgia O'Keeffe ("In a way, nobody sees a flower really. It is so small, we haven't the time—and to see takes time, like to have a friend takes time"), and

dancer Isadora Duncan ("I was born by the sea and I have noticed that all the great events of my life have taken place by the sea. My first idea of movement, of the dance, certainly came from the rhythms of the waves").

Invite students to use pencil on newsprint to work through sketches for their ideas for a structure that would be so interesting, people would want to look inside. They should keep in mind the flowing organic forms of Wright's and Gehry's Guggenheim designs.

Once students have determined a design approach, they should use the vellum paper to create a structure that is both functional and visually interesting, using white glue or rubber cement to hold the structure together. (Rubber cement may be the more effective adhesive for holding thin paper edges together. Safety note: Use rubber cement only in areas of active ventilation.) Before assembling their structure, students should compose text on the white vellum paper as necessary to incorporate their artist's quotation. The works will benefit from experimentation with placement of forms in the structures. Remind students to look at the structures from all angles before they make final decisions. Students should pay careful attention to shadows, the direction of movement in the piece, and keeping the edges and joints clean and neatly glued.

1-23 Jesse Kirsch
This piece captures the rhythmic flow of the ocean as it reflects on the words of dancer Isadora Duncan.
White vellum, 17" x 18" x 9"
(43.2 x 45.7 x 22.8 cm).

Evaluation

Ask students: Is your architectural book artistically readable? Does it invite the viewer to look at both the inside and the outside? What impression will your work leave on the viewer?

Results and Observations

This project helped students develop an appreciation both of architecture and of handmade books. They enjoyed and learned from the experience of combining a three-dimensional structure with an inspiring quotation that celebrated their chosen artist.

Conclusion

In both books and architecture the outside indicates but does not completely define what is to be found in the interior. The attraction to a book's cover or the exterior of a built structure is only an indication of what lies inside; the interior must be explored in order for the whole to be understood. Offering students an opportunity to make connections between architecture and artistic books brings greater insight into the cultural significance of these designed objects.

1-24 Hee Won Shin
Symmetrical balance combined with repeated text offers visual unity to the overall form, which pays homage to Frost ("Two roads diverged in a wood . . .")
White vellum, 17" x 11" x 11"
(43.2 x 27.9 x 27.9 cm).

Jenifer Chen
Paper, 12" x 24" (30.5 x 61 cm).

Simple Materials Create Dynamic Results

I feel students often overlook the potential of the natural resources available to them. Too often we resort to buying art tools and materials rather than creating them on our own. We live in a throwaway society, yes, but as artists and teachers we can counter this trend by promoting the use of simple everyday materials, including recycled items and natural resources, to provide richly rewarding artistic experiences for our students. The visual problems explored in this chapter instruct students in applying the use of everyday materials in a variety of media. In addressing the challenges posed, students may be expected to find new avenues of personal expression and artistic vision.

Asian Painting and Artistic Handmade Drawing Pens

Inspiration

Having returned from a recent trip to Japan, I felt the desire to increase my students' knowledge of Asian art and culture. My personal experience with Asian brush painting was surely a motivation for this project, which first introduces students to the art of brush painting and then allows them to develop their own unique bamboo pens and to use them in creating their own brush painting. On my New Jersey property, I had access to an adequate supply of live bamboo, which I cut into lengths of varying thickness in easily transportable pieces for my students' use in the classroom. Ultimately, I hoped that this experience would encourage my students to learn about and develop an appreciation for the art of eastern cultures.

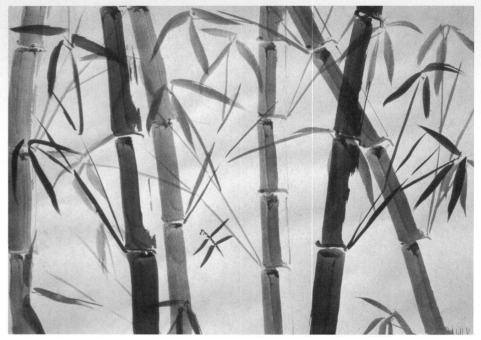

2-1 Jill Vanzino
Live bamboo was placed in the center of the room so that the students could understand its structure.
India ink, 18" x 24" (45.7 x 61 cm).

Visual Problem

In Part 1, students will apply the techniques of Asian brush painting to create two large value study images of bamboo plants. In Part 2, students will create their own bamboo drawing instrument, which they will personalize using a variety of decorative materials. As a follow-up activity, students will study haiku and write their own haiku, creating a final image using their bamboo pens to illustrate their haiku poem.

Time

Nineteen 45-minute periods: 7 for practice and final value study in brush painting; 8 for carving and personalizing pens; 4 for developing final drawn image incorporating haiku

Student Choices

- design of the bamboo pen
- source image for haiku poem
- creation of haiku
- use of watercolor media, if desired

Materials: Part 1
- 12" x 18" newsprint
- 18" x 24" white vellum
- black India ink
- bamboo brushes in varied sizes

Start-up Activity

As a pre-assignment, students were shown examples of block prints and bamboo brush paintings and asked to research and share insights into the culture of various Asian countries. Next, I shared my freshly cut bamboo samples and specific information about bamboo and its various uses, pointing out the alternating leaf structure of the bamboo plant. Bamboo is known for and is symbolic of both flexibility and strength. In its green state, it is easy to cut and the finer branches are easy to bend. When bamboo dries, its green color fades to tan, and it becomes very hard and durable.

Process
Part 1

For the practice stage of the brush-painting exercise, students used newsprint paper (12" x 18"), watered-down black India ink, and bamboo brushes. Because brush painting requires the artist to lift the brush after making each mark, it requires a confidence and spontaneity in the artistic process. The formal painting technique involved in the execution of this process promotes in students a careful attention to detail.

Asian bamboo paintings show simplicity and a rich understanding of negative space. For this exercise,

Bamboo Brush Painting Technique

The traditional technique requires holding the brush vertically and not allowing one's arm to rest on the table. Due to the expense of black ink, I chose to dilute the ink with a small amount of water to create a rich black medium. Additional water can be added to produce gray values. To begin, I suggest that students paint a series of vertical strokes, pausing in between strokes to lift the brush completely off the page. The idea is for each stroke of the brush to represent a single leaf or an individual segment of the bamboo stem. An additional brushstroke that looks like a horizontal Z is placed in between each segment. This will emphasize the division in the structure of the bamboo. It is at these junctures that two smaller branches emerge. These alternating branches and leaves are seen in both the stem and along the branches. Leaves are applied to the ends of these small branches in sets of three. Each leaf is painted with one downward brushstroke. Overlapping leaves and shades of gray create depth and add a more natural feel.

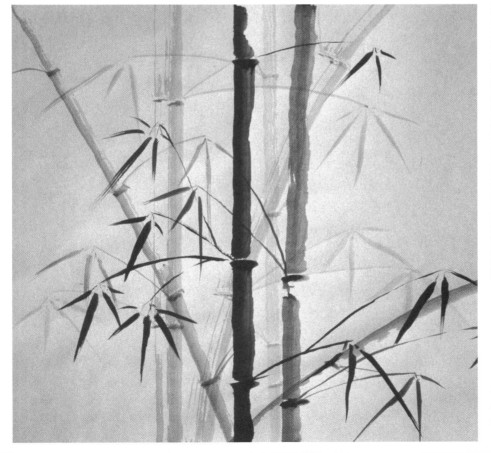

2-2 Zeven Rosser
Asian brush painting aims to balance black and gray scales for visual harmony.
India ink, 18" x 24" (45.7 x 61 cm).

I asked students to consider the balance of thick and thin, light and dark, and the positive and negative shapes in the overall composition. Dry brush can be used to create the idea of a light source. This is possible as less ink is used and additional pressure is applied to the surface of the paper during the painting process. Right-handed students using this technique will create the effect of light on the left side of the bamboo segments. Light gray is used for the bamboo in the background while a darker value is employed for the foreground subjects. Note: the value of the stem is the same value used in the smaller branches and leaves.

For their final paintings, students used large sheets of white vellum (18" x 24") and a stronger consistency of black ink for the darker values of their composition.

Evaluation
Part 1
Ask students: Does your work reflect a visual balance of black and gray value? Do you see the significance of applying each brushstroke and not retouching? After learning this technique, did you gain a sense of confidence as you continued to apply the brushstrokes to the paper?

Results and Observations
Part 1
A great deal of practice on newsprint occurred before the students felt ready to go on to their final on white paper. They observed their own progress and success based on the criteria of balance of thick and thin shapes and of light and dark value study. Some students were amazed at how difficult the painting technique was in the beginning, yet all were pleased with their increased understanding of the process and improved results at the end. Freedom of expression is seen, as each student applies brushstrokes in unique and definitive ways.

Process
Part 2
Have students physically hold and observe the structure of the fresh-cut bamboo plants. They will notice that bamboo is segmented and naturally breaks every several inches, depending on the size of the plant. It is at these natural breaks that two new small branches emerge. These breaks have ridges that provide natural places for the human hand to hold. Students should pick their own individual length and thickness to work with.

Next, I asked students to compare

Materials: Part 2
▶ bamboo (fresh-cut plants)
▶ Stanley knives and X-Acto knives
▶ A variety of readily available materials such as colored embroidery thread, fine craft wire, feathers, colored string, and metallic markers
▶ a woodburning tool
▶ Duco cement or 5-min. epoxy

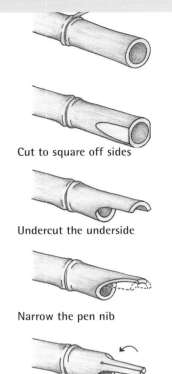

Cut to square off sides

Undercut the underside

Narrow the pen nib

Cut a center line and add a small hole to finish pen nib

2-3 Creating a pen nib from natural bamboo.

the structure of both a regular metal pen nib and a bamboo pen nib. To create their own pen (see diagrams this page), students begin by using a Stanley knife to cut the end of their bamboo into the shape of a pen nib. This is done first by squaring off the rounded form of the two sides, followed by undercutting the bottom side. Then the top is narrowed and pointed. A vertical slit is made along the new tip to allow the ink to flow. A small hole is created (using an X-Acto knife) at the end of the slit to prevent the

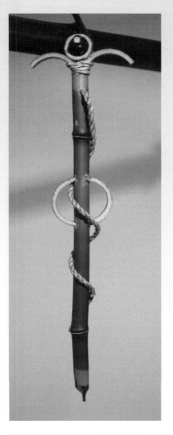

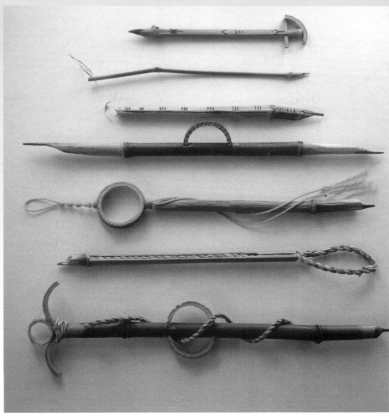

2-4 Lauren Jones
Handmade hemp rope was added to create visual unity in this pen.
Bamboo, hemp, 5" (12.7 cm).

2-5 Student pens exhibited both diversity and personal expression.

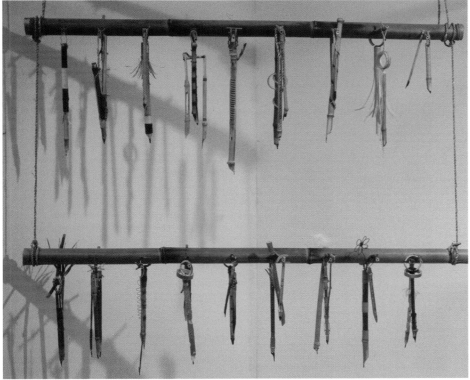

2-6 Student pens were hung on this structure for daily storage as well as final exhibition. Note that holes were drilled into two larger pieces of bamboo so that small bamboo branches could be used as hooks.

bamboo from splitting further. The X-Acto knife is used to refine the final shape of the bamboo nib.

Once the pen is cut, it is ready to be tested for its workability. The nib can be refined more if necessary. Have students personalize their pen using a variety of other materials.

For the final presentation stage, students are asked to develop a creative way to hang up their drawing implement. Final presentation is

Asian Painting and Artistic Handmade Drawing Pens **29**

critical to completion of this studio experience, and it is important not to miss the opportunity to have students respond to this consideration.

Evaluation
Part 2
Ask students: Does the drawing instrument actually work? Have you demonstrated that? How is the pen you created aesthetically attractive? What materials other than bamboo did you use? Is your pen so visually engaging that the viewer wants to reach out and pick it up?

Results and Observations
Part 2
Students exhibited great enthusiasm for the opportunity actually to create a pen and even more when they realized the pen worked! Most students chose to create more than one pen as they worked through the carving and personalizing stages. Students used various approaches to personalizing their drawing instrument. A woodburning tool was used for burning incised lines and designs.

In response to my desire to create some kind of large pen holder for my students to hang their pens from, a colleague supplied me with a few thicker pieces of bamboo that I was able to use for display purposes. The larger, freshly cut bamboo was 1½"–2" in diameter. These pieces were 36" in length and were hung horizontally using handmade rope suspended from the ceiling of a glass showcase. This process was begun by drilling holes through the

large pieces of bamboo every three to four inches and inserting smaller branches through to the other side. Students could then hang their pens from either side from these smaller branches. The two large horizontal poles held about forty-five pens and provided a bamboo-inspired design for displaying the student work.

Some students bent a branch of thin bamboo to create a loop for hanging their drawing instrument. Other students cut a hole or used string or wire as a way of hanging their pen. The angled branches also created a natural device for hanging. The solutions were as varied as their pens.

Follow-up Activity
As a follow-up activity to Part 2, I

2-7 Zeven Rosser
A postcard photograph was used as a jumping-off point for the student's haiku and illustration.
Black India ink, 8½" x 11" (21.6 x 27.9 cm).

asked students to select an image from a series of postcards of Asian art images I had purchased from the Metropolitan Museum of Art in New York. This activity might be accomplished with any set of images drawing on the art of Japan, China, Korea, or Southeast Asia. Students were encouraged to create a haiku poem using their chosen postcard as a source subject.

After the haiku is written, postcards are returned. Students should use their individually made pens to write a final draft copy on a sheet of white vellum (9" x 12"). They will consider the placement of words in order to have space to illustrate their image. They will create a new image, based on and motivated by their words and not of the postcard image selected. Watercolor can be added to the drawn pen-and-ink image that illustrates the haiku.

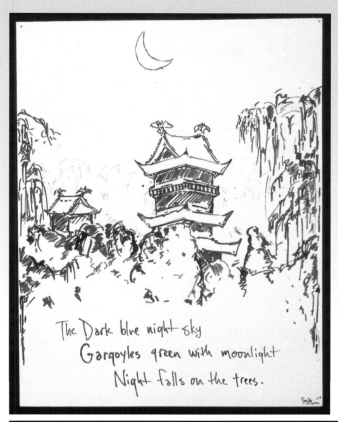

2-8 Tarik Parez
The student-created pens were used for both the haiku lettering and the drawing.
Black India ink, 8½" x 11" (21.6 x 27.9 cm).

The Dark blue night sky
Gargoyles green with moonlight
Night falls on the trees.

Conclusion

The two projects and follow-up activity that make up this studio experience offered students an appreciation for Asian brush painting, for making their own painting instruments, and for the care and subtlety with which traditional Asian art is created. During the course of this three-week project, the art room was filled with images of Asian art as well as 10" cuttings of bamboo for student observation. Designing pens presented a fun yet challenging way for students to explore their ability to create their own drawing instrument. The illustrated haiku was a very successful conclusion to this project because it combined creation of an illustration with a creative writing element, making practical usage of the students' newly developed pens.

Exploring this area of non-Western art proved an excellent way to broaden my art curriculum. Having originally worried that, as a westerner, I would be unable to do justice to Eastern art—to succeed in giving students an appreciation for the simplicity and richness of the art's expression—I found the research, planning, and artistic process connected with the project to be well worth the effort.

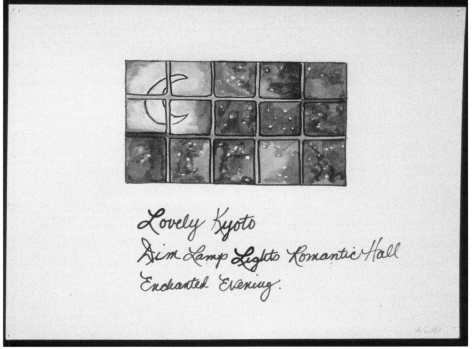

Lovely Kyoto
Dim Lamp Lights Romantic Hall
Enchanted Evening.

2-9 Amanda Biddle
Works such as this one show a thoughtful relation of haiku to image.
Black India ink, 8½" x 11" (21.6 x 27.9 cm).

Sculptural Shoes

Inspiration

Have you ever noticed the vast variety of styles, forms, and materials in which shoes are created today? Shoes have always been statements in style, but in recent years, technology has allowed manufacturers to produce them using more varied materials than ever before. In seeing the sculptural qualities in a vast variety of shoes, I began to wonder if high school students might be able to see shoes as sculpture or as objects to be reinvented as sculpture.

One motivational resource for this project, a book I purchased at the Renwick Gallery, Washington D.C., Cinderella's Revenge, *by Samuele Mazza (Chronicle Books, 1994), shares artists' work inspired by the basic forms of shoes while creatively developing diverse and visually engaging sculptural images.*

Visual Problem

Students are to construct a pair of sculptural, life-size shoes using simple brown paper grocery bags.

Time

Fourteen 45-min. periods: 1 for contour line drawing, 3 for development of paper model, 10 for development of final paper shoes

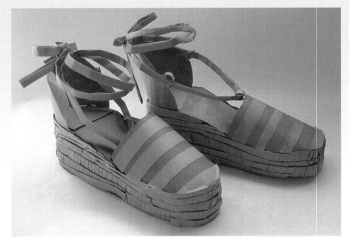

2-10 Jackie Wendroff
The twisted and folded strips of paper create texture on the soles of these shoes.
Brown paper bags, life-size.

Materials
- brown butcher paper (roll)
- brown paper grocery bags
- masking tape, rubber cement, white glue
- scissors

Student Choices
- style of shoe
- size—life size or larger
- bonding agent

Preactivity

Instruct students to draw three pairs of shoes in their sketchbooks over a three-week time period. These are to be pencil drawings, done one per week as homework. The drawings can be done just in line or they can be in value study; at least one hour should be spent on each observational drawing. Students are encouraged to make

their selection based on their own criteria. (Examples: "These are the coolest shoes I own," or "These are the ugliest, oldest, most comfortable, etc.") Each week a group critique takes place where the student work is analyzed, encouraged, and validated for its use of line, value, or clarity of its three-dimensional qualities.

Start-up Activity

Share images of various kinds of shoes, exhibiting a diverse range of styles. My examples were wooden shoes from Holland, ballet toe shoes from the United States, and handmade woven sandals from Japan. Show examples of artists who use shoes in their work. Students saw two images painted by Vincent van Gogh—*Wooden Shoes,* Arles, 1888; and *Boots with Laces,* Paris, 1886–87. Discuss

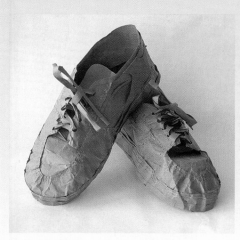

2-11 Lila Symons
The student who created this work learned how to use a sewing machine to stitch its components together. The final effect is of an old and well-worn pair of shoes.
Brown paper bags, life-size.

shoes in terms of style and diversity but also as something seen to represent varied sculptural forms.

Process

Students begin by deciding the kind of shoes to be developed in this sculptural process. Their choice need not be one of the original examples drawn in their sketchbooks.

Students use cut paper (inexpensive butcher paper), scissors, and masking tape to create a model of the shoe's size and shape. Creating this model, students will work through the basic shapes and overall design. Students can deconstruct this model, if they choose, to use as a pattern for the final sculpture made with the heavier brown paper.

Students use ordinary brown grocery bags for the final paper sculpture. Instruct students that craftsmanship is important and that any

bonding material such as masking tape, white glue, or rubber cement should not be visible to the viewer on the final sculpture.

Evaluation

Ask students: Are the shoes you constructed well proportioned? Do they look like they go together? How well crafted are they? Is the bonding agent you chose showing? What was the most difficult aspect of the process and how did you overcome it?

Results and Observations

Most students used one of the pairs of shoes they originally drew in their sketchbook, even though they could have chosen another pair for their subject.

There was frustration in the beginning process, and until the first thin paper model was con-

structed, because there are many technical decisions to be made in shaping the thin paper into the first three-dimensional form.

Many students deconstructed the thin paper model and some even labeled each piece before using it as a pattern for the final form. Others created one complete shoe and copied each shape to create the second.

Students cleverly figured out shoelaces—created of twisted paper—buckles that actually work, and even decorative patterns and textures on different areas of the shoes and soles.

One student used natural-color thread to add the desired stitching effect, adding texture to her interpretation of well-worn sneakers (fig. 2-11). Many chose to work at home to develop the finished pair of shoes within the allotted time

2-12 Michelle Baker
Thin corrugated cardboard adds real texture to these finely crafted shoes.
Brown paper bags, life-size.

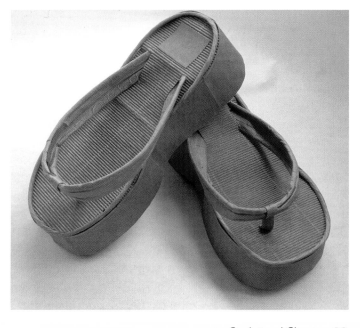

frame. The life-size sculptural results showed both skill and quality in craftsmanship.

Conclusion

When the students were assigned the three original homework exercises, they were unaware that they were going to be directed into a three-dimensional project. By beginning with an observational drawing exercise, students studied the form in detail. This was an excellent lead-in to this sculpture project. They first observed three-dimensional shoes, translated them into two-dimensional drawings, and then transformed that information back into a three-dimensional sculpture.

This is a demanding project, yet producing two shoes is not twice as difficult as producing one, as I had first perceived. The thinking through of the first shoe made the second one easier to develop. Doing a pair just added to the challenge, greater thinking, and more decision making on the part of the student.

Twenty pairs of paper shoes were chosen to fill a showcase nearby to the art room. This exhibition space contained a poster that stated: "Shoes seen for their sculptural qualities." A half dozen shoeboxes were used to create podiums on various levels, and some shoes were hung from the ceiling of the showcase, while four pairs were cantilevered from the sides. The end result looked like a shoe store window filled with a vast variety of styles, shapes, and sizes. Due to the

quality of craftsmanship and the identifiable subject matter of the pieces displayed, this exhibition generated very positive feedback from a broad cross section of the school population.

This problem-solving process, using ordinary brown grocery bags to create sculpture, led to exceptional results. Students increased their knowledge about structure and construction techniques while producing overall matching forms.

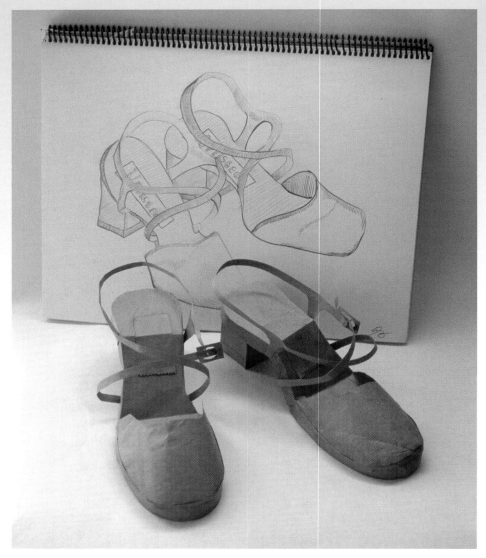

2-13 Amanda Biddle
Preparatory pencil drawings were an important part of this sculpture project.
Pencil, brown paper bags, life-size.

Texture Collage

Inspiration

For a number of years I have held on to colorful posters advertising art institutes and colleges. These posters are printed on sturdier stock than magazine advertisement pages, and therefore serve as a more textured, and more durable, medium when used in collage. I decided that recycling these posters in an art project would be an excellent way to teach about texture, color, and the process of creating a collage.

Visual Problem

Students will select, study, and draw a single creature from nature (animal, insect, bird, or fish) to be used as their collage subject. Students will use only torn paper, developing their chosen subject with both color and texture.

Time

Ten 45-minute periods: 2 for warm-up and initial contour line drawing; 2 to transfer to poster or illustration board; 3 to select and tear collage pieces; 3 to place and glue collage pieces

Student Choices

- subject and composition
- use of color

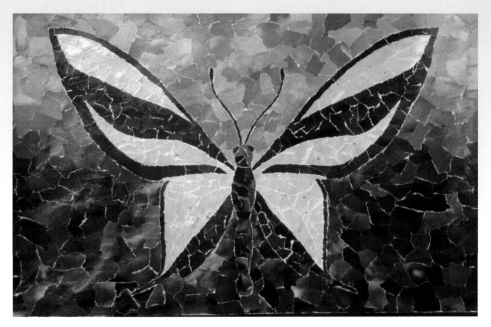

2-14 Jenifer Chen
This symmetrically balanced image's use of color is strong enough to maintain visual interest.
Paper, 12" x 24" (30.5 x 61 cm).

Preactivity

In the library or online, students research and select their chosen natural subject. They are also encouraged to view images by artists who successfully combine color and texture. Vincent van Gogh's paintings are excellent examples. Viewing van Gogh's work, students should pay particular attention to the way he used oil paints to combine rich color and applied texture.

Process

Students create a light contour line drawing of their chosen subject. This is first done on newsprint (12" x 18") before being transferred

Materials
- newsprint (12" x 18")
- recycled posters or other poster-thickness collage materials
- white vellum (12" x 18") (80 lb.)
- white glue diluted with water (3:1)
- watercolor brushes

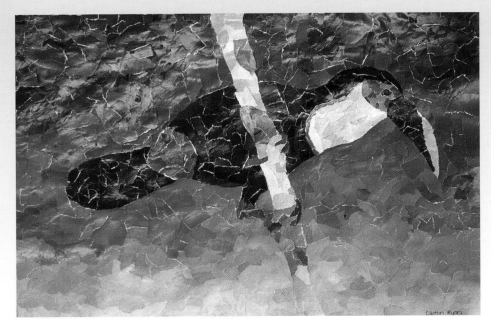

onto white vellum (12" x 24"). Ask students to work large and to consider the use of negative space in the composition.

Students decide on the color of their subject and background. They begin the process of collage by tearing and pasting the poster images and applying them onto their drawn image.

Using watered-down white glue, students use inexpensive soft watercolor brushes to brush the paper with glue before applying the torn pieces to their drawing. Students are asked to proceed slowly and thoughtfully as they develop their image. To secure the images, brush a thin layer of glue on the top surface of the torn paper

Share images of artists' work, such as van Gogh's, that show a combined use of both color and texture.

Evaluation

Ask students: What role does texture play in your collage? How is color used in your collage and how is its repetition helpful in creating unity? Do you see a relationship between the use of color and texture in your work and that of the paintings of Vincent van Gogh?

Results and Observations

It is important for students to work large in developing their main subject, because the paper-tearing process can naturally lead to a loss of detail. Working small would have required the use of tweezers. The torn paper method added texture to the overall image.

Students realized that by completing the entire image, taking into account both subject and negative space, they created visual unity in both the use of materials and in their developed subject.

Poster or illustration board are desirable materials to use for this process. This avoids the warping that takes place when using thinner paper as the base. Glossy magazine covers in particular are to be avoided as collage materials, as the shiny covers printed with ultraviolet-cured inks or coatings contain a clay content used as a stabilizer. When glue is applied to coated paper, the clay is moistened, and printed colors tend to run to a grayish white.

2-16 Marcellia Reves
The torn-paper edges provide textural unity to this project.
Paper, 12" x 24" (30.5 x 61 cm).

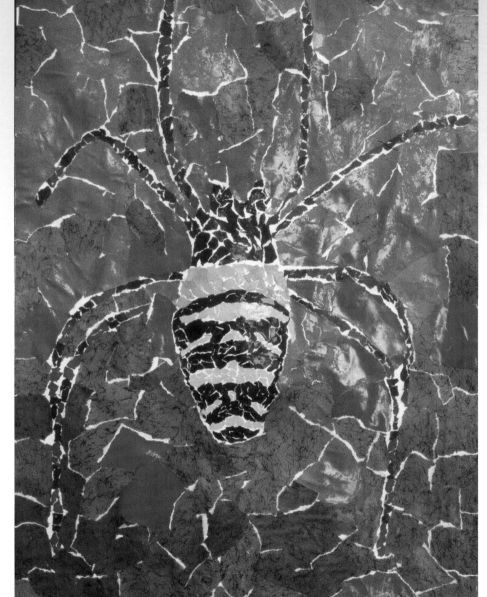

Conclusion

This collage process is often done using magazine images, yet students can get hung up in the text of magazines, losing track of the specific color they intended to look for. The poster materials we used for this project offered a vast variety of both color and texture. I strongly recommend teachers seek poster-thickness recycled paper, rather than magazines, for use in collage. The student results were impressive, showing care in use of materials, strong use of color and texture, and a variety of expressive effects.

Whimsical Witty Wire Drawings: A Calder Inspiration

Inspiration

Part of the genesis of this project was receipt in my art room of a quantity of donated recycled wire, a large container of old buttons, and some old electrical parts. This variety of materials was perfect incentive to do this creative project, the fine arts touchpoint for which is Alexander Calder's wire sculpture circus, which combines thoughtfully structured linear forms to create a whimsical, child-like fantasy world. I hoped that creating three-dimensional linear structures in the spirit of Calder's circus figures would offer students a wonderful opportunity to make connections between the processes of drawing and sculpture.

Visual Problem

Students will create gestural wire images of the human form. They will be created using a variety of wire, buttons, and recycled electronic parts.

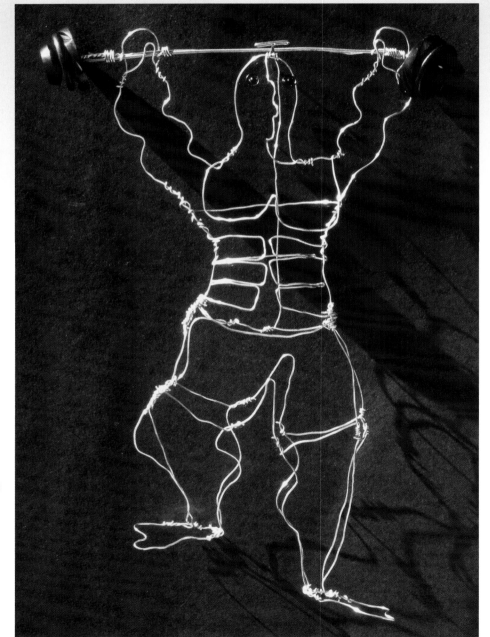

2-17 Meredith Ally
Varied-size buttons were used to create the barbells hoisted by this muscle man.
Aluminum wire and buttons, 10" x 7" x 3"
(25.4 x 17.8 x 7.6 cm).

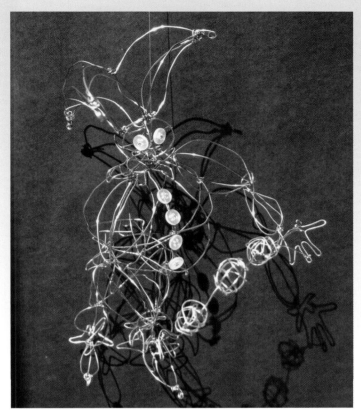

2-18 Jesse Kirsch
This juggling jester combines movement with quality craftsmanship.
Copper wire and buttons, 12" x 7" x 7" (30.5 x 17.8 x 17.8 cm).

Materials

▶ varied kinds and thicknesses of wire (copper, brass, and electrical)
▶ recycled buttons
▶ recycled electric parts
▶ varied sizes of pliers and wire cutters

Time

Twelve 45-minute periods: 1 to introduce the lesson, 10 to develop the sculpture, 1 for critique

Student Choices

• subjects and their development

Process

Students begin by becoming familiar with examples of wire sculpture, including Alexander Calder's flying circus. They continue by producing gestural line drawings of the human form. Subjects can include sky divers, pole vaulters, gymnasts, dancers, etc. Students' choice of subject is drawn in their sketchbooks. These loose linear drawings will help to plan how the wire is used in this project.

Limit the size of the sculptures if only small quantities of wire are available. I selected 10" as the basic length for each wire. Students are asked to transpose the line drawings from their sketchbooks into wire forms. Wrapping, tying, and knotting will secure joints. A variety of pliers and wire cutters are provided through the entire process.

Students are encouraged to use resources sparingly. The end results will be thoughtfully constructed linear wire forms emphasizing economy of line.

Students are asked to think two-dimensionally for their first wire image. Their work will be completely flat, replicating their line drawing from their sketchbook. Students are then asked to continue to cut, bend, and manipulate the wire to create a three-dimensional human form.

Working with varied wire, buttons, and electrical parts can naturally bring a sense of the fantastic to sculptures. Students are asked to exaggerate various qualities of the human form in order to add a witty or whimsical quality.

After the students completed their initial flat wire image they had a good understanding about shape and use of materials to then develop a three-dimensional second image. Students are encouraged to use thicker wire when working three-dimensionally as it offers support to maintain the overall form.

Evaluation

Ask students: What makes a subject whimsical? How can art reflect humor? How does your work reflect flow and movement? How does the viewer's eye follow through the linear qualities in the sculpture you developed?

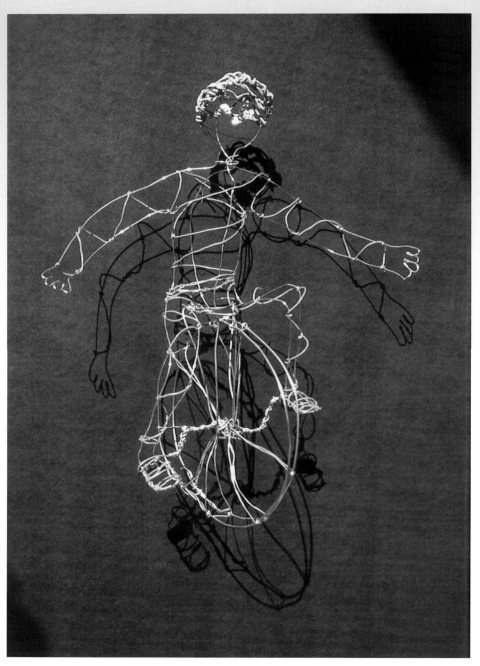

Results and Observations

Transposing linear drawing into wire offers the opportunity to use line three-dimensionally. The initial process of bending, cutting, and manipulating wire proved to be a challenging yet positive experience.

Stressing economy of line will translate to economy in the use of wire. Students were very successful at improving their awareness and understanding of the use of line in both two- and three-dimensional settings. Students learned a great deal by transferring their initial pencil drawings into wire sculptures.

Conclusion

As students think three-dimensionally, they are intentionally directed to become more aware of how the viewer's eye visually moves through their work. The transition from two to three dimensions worked very well by transposing two-dimensional pencil drawings into three-dimensional lines in space.

The two-dimensional work was mounted on colored illustration board using fine wire for exhibition purposes. The three-dimensional works were hung from the ceiling or displayed as freestanding structures.

2-19 Maria Chiriboga
The qualities of movement and balance contribute to this unicyclist's appeal.
Aluminum wire and telephone wire,
10" x 9" x 5" (25.4 x 22.9 x 12.7 cm).

Calder-Influenced Bird Sculpture

Inspiration

The Phillips Collection in Washington, D.C., has one very special work of art by Alexander Calder that is not one of his better-known mobile structures. Only Only Bird (11" x 17" x 39"), a single form created from recycled tin cans and wire, shows both the visual unity and strong use of color also to be found in Calder's more famous structures. I believe this single floating sculpture may be unique to his body of work.

An increasing awareness of the amount of aluminum in the form of cans being discarded daily in our school cafeteria provided an incentive to have my students create a metal sculpture. With Calder's example in mind, my students were motivated to create a variety of whimsical three-dimensional forms using aluminum.

Materials
- sketchbooks
- aluminum cans (approximately 10 per student)
- coat hangers
- fine wire (18-gauge copper or brass)
- wire cutters, pliers, scissors, compasses
- 5-min. epoxy
- nylon thread (10 lb. test)
- spray paint (optional)

Visual Problem

Using recycled metal materials, students will create a whimsical bird sculpture that reflects the unique qualities of rain forest birds.

Time

Fifteen 45-minute periods: 2 for creation of preliminary bird images; 13 for creation of bird structures

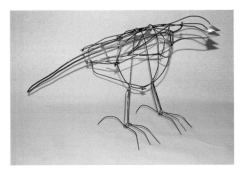

2-20 Jesse Kirsch
This wire armature was created using coat hangers and fine copper wire.
Coat hanger, copper wire, 17" x 24" x 18" (43.2 x 61 x 45.7 cm).

2-21 Jesse Kirsch
The silver inside of the aluminum can turned inside out provides a unifying color to the finished work.
Aluminum, coat hanger, and copper wire, 17" x 24" x 18" (43.2 x 61 x 45.7 cm).

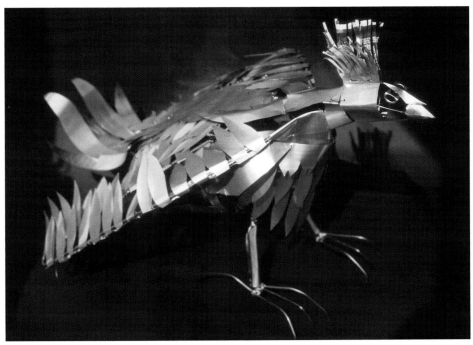

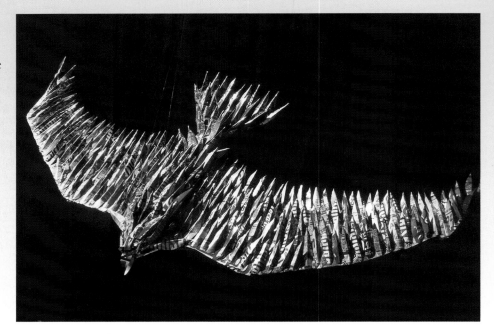

2-22 Rishi Roongta
This student's personal challenge was to create the largest and most colorful flying bird sculpture.
Aluminum, coat hanger, and copper wire, 5" x 55" x 24" (12.7 x 139.7 x 61 cm).

Preactivity

Over time, students collected hundreds of aluminum cans, coat hangers, and wires. A large storage box was placed in the art room for this purpose. Students then researched the unique structures of tropical birds from the media center and the Internet in order to prepare the appropriate visual information and materials.

Share the varied contributions of sculptor Alexander Calder. Note the beautifully articulated floating mobile structures, the simple dynamic shapes found in his stables, and his other bold two-dimensional images seen in print. Focus on the whimsical attributes of his works, such as those found in his circus images (*The Circus*, 1932, ink; and *Little Circus,* 1961, film). As mentioned, his *Only Only Bird,* from 1952, was a catalyst for this project.

Process

Students begin by researching and drawing a series of tropical bird images in their sketchbooks. As they note the shapes, color, and overall varied structures found in these rain forest birds, they create a series of preliminary sketches showing both the form of the bird and its varied parts. These sketches serve to develop observational drawing skill levels and increase visual awareness of the chosen subject. Students can then use their awareness of the actual structure to distort or exaggerate the form in expressive ways.

Students are encouraged to create fanciful, whimsical sculptures based on the structure of birds. The diversity of forms and colors will perhaps bring greater appreciation for the creatures that live in the precious ecological environment of the rain forest.

Students begin the construction process using a compass or an awl to puncture an aluminum can before regular classroom scissors are used for cutting shapes into it. It is best to cut off the top and bottom first, creating a rectangle of aluminum before cutting the smaller shapes needed. Students are advised to think in terms of the bird's body parts and how they will be cut, shaped, and eventually joined together. Coat hangers are perfect for body armatures, wings, and legs. Some coat hangers are thinner and easier to cut than

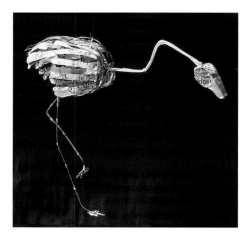

2-23 Meredith Ally
This walking flamingo gives a powerful impression of movement. The viewer can see through the feathers into the structure of the body.
Aluminum, coat hanger, and copper wire, 19" x 19" x 6" (48.3 x 48.3 x 15.2 cm).

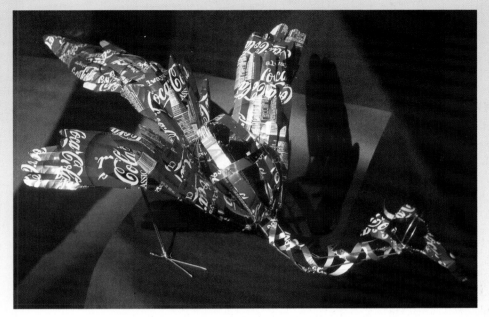

2-24 Mike Matejek
This sculpture's unity is achieved by exclusive use of a single type of soda can.
Aluminum, coat hanger, and copper wire, 12" x 22" x 30" (30.5 x 55.9 x 76.2 cm).

others. Scissors are used to cut the flat aluminum that will be used for the feathers and other body parts. Wooden sculpture tools can be used to manipulate the individual aluminum shapes, as in a repoussé process. This relief process is accomplished by pressing the aluminum over a wadded pad of newspaper so that the metal surface gives, resulting in a creased low relief texture for the feathers. Fine wire and wire cutters are used to connect feathers to wings and wings to bodies. Students can use five-minute epoxy, which is a strong bonding agent, to secure elements where thin wire is impossible to use.

Student Choices

- type of tropical bird and creative interpretation
- size and color

Evaluation

Ask students: What are the qualities that make any subject whimsical? In terms of craftsmanship: How strong is your final structure? How well is it made? What did you do to visually unify the overall sculpture?

Results and Observations

Aluminum cans are easy to acquire, manipulate, and restructure. Aluminum is very easy to cut with classroom scissors, which makes creating feathers simple. Thin wire worked well to secure each individual part.

Having a quantity of cans can allow students to make mistakes and start again. At the end of each class, sharp or irregularly cut pieces of aluminum should be discarded to avoid cut fingers.

Recycled plastic grocery bags are used for storage of the cut aluminum cans and other metal parts. A permanent marker is used to identify students' names on each

plastic bag, which were hung on a clothesline from the art room ceiling. This clothesline storage method was very successful, as the bags held all of students' smaller pieces in one location.

As the project evolved, the work was transferred to available shelf space or suspended from the ceiling. Students were then able to appreciate each others' structures in progress. Some students chose to create an armature using coat hangers while others depended on aluminum cans to create the body of the bird. The type of material students chose made a difference. The more challenging structures were clearly created using the wire armatures. Aesthetically, the birds created using the coat hanger armatures tended to be more serious in nature and therefore less whimsical.

Conclusion

The artistic example of Alexander Calder provided a useful model of how artists create whimsical structures. Through this visual problem students increased their awareness and understanding of the varied structural qualities of birds and of form in sculpture. They also experienced greater knowledge of how to create three-dimensional forms using recycled materials and thus were better able to utilize this information to creatively develop their own unique image.

Siena Artuso
Oil pastel, 96" x 48" (243.8 x 121.9 cm);
detail.

Encouraging Personal Expression

This chapter will consider ways to engage the adolescent mind in the expressive and reflective aspects of the learning process. We, as artist-teachers, have an opportunity to help our students reflect and understand their adolescence. We can offer them a symbolic introspective mirror that looks at the diversity of the thinking, moods, and emotions that they experience on a daily basis. In doing so we are offering our students opportunities for greater understanding and personal expression.

As any teacher knows, adolescents are by nature selective in the ways they choose to reveal themselves. And yet, when the value of personal expression is understood and shared, a level of trust and confidentiality acknowledged and addressed, student expressive confidence rises. This process is best achieved in small, comfortable steps. The series of selected projects in this chapter shares this progression.

The Engaging Garden No. 2

Inspiration

The work that inspired this project caught my eye during a trip to the Corcoran Gallery of Art in Washington, D.C. Dangerous Garden *(1994), by the American artist Joseph Norman (1951–), a large diptych drawn in charcoal and black ink on paper, offers the viewer a disturbing view of an abandoned garden. Norman's use of rich blacks in a jumbled abstract composition offers a quality of menace that directly engages the viewer.*

I began to look for other works that elicited unexpected emotional responses. I decided my students could benefit from an imaginative drawing project in which a viewer becomes engaged on a perhaps surprising emotional level.

Visual Problem

Students will create a bold and engaging image based on the physical properties of a garden. Through strong composition, distortion, and visual tension, they will transcend the traditionally welcoming symbol of a garden as a place of beauty and comfort, creating instead an image of an environment that is mysterious, or even uncomfortable or threatening.

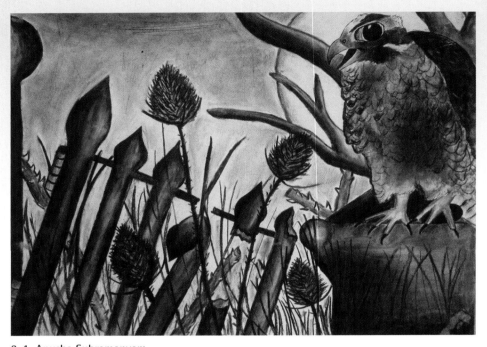

3-1 Anusha Subramanyam
This drawing's rich value and use of diagonal lines create sustained visual interest.
Charcoal, 18" x 24" (45.7 x 61 cm).

Materials

- 12" x 18" or 18" x 24" sheets of white vellum
- charcoal (pencil or vine)
- white chalk
- black India ink
- watercolor brushes and/or ink pens
- kneaded erasers and blending tortillon
- fixative spray

Start-up Activity

Begin by talking about the expressive qualities of images that are disarming, foreboding, or disturbing. Point out that artists frequently modify or distort their subjects in order to create images that are thought provoking and cause an unexpected emotional response. Ask, "What are the qualities that create mystery in an artist's image? How does an artist create or reinforce these qualities through composition and color choices?"

Continue by sharing examples of a variety of artists' works that are engaging and thought provoking. Note how many of Edward Hopper's paintings communicate a sense of aloneness or loneliness, and how Hopper's dynamic lighting impacts his subjects. Note how, in Picasso's nonrealistic portrait style, the angularity and distortion of his subjects offers the viewer a sense of visual tension. Two images by Ben Shahn also create a visual uneasiness. The *Blind Botanist,* serigraph prints No. 7 (1961) and No. 8 (1963), show a botanist whose hands are working on a very large thorny plant that even a sighted person would be reluctant to handle.

To prepare physically for this project, bring together a variety of garden props. My collection of objects included a small Victorian iron window gate, a couple of old wooden rakes, bunches of dried thistles, rosebush branches, and an old stuffed owl. These are not put together as a still life but are intentionally placed in different areas of the room. The students will creatively put these elements together, adding anything else they choose, including a human form should they desire.

As final preparation, I asked my students to reflect on fairy tales or other forms of literature in which an author has created environments with imposing qualities. How do the authors communicate those environments to the reader?

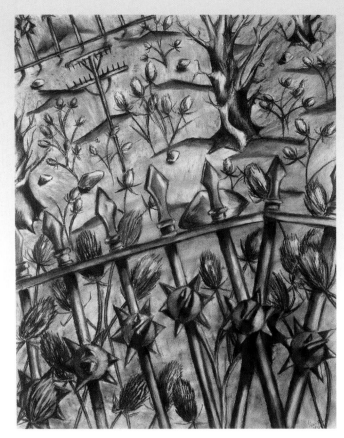

3-2 Sean Keeton
This image's spatial depth captures a feeling of isolation and emptiness. Charcoal, 18" x 24" (45.7 x 61 cm).

Process

I suggest that students use a wide range of values—rich blacks to light grays—in creating their imaginary image, creating depth by overlapping or layering the objects in their composition. Students were encouraged to enlarge, reduce, or distort the garden objects seen in the classroom.

They were free to enlarge the composition with additional paper beyond the 18" x 24" size.

I provided students with a list of words to think about:

abandoned
disarming
disturbing
foggy
foreboding
misty
mysterious
overgrown
threatening
uncomfortable
untamed

This kind of list provides a visual reference for students as they work.

Explain that in developing an image that is mysterious, edgy, foreboding, or even creepy, students need to avoid violent imagery such as that of dead bodies, severed heads, or blood. The goal is subtlety

in expression, so heavy-handed imagery should be discouraged.

Students should begin by developing compositional drawings on newsprint paper. These can include all or just some of the garden props provided in the classroom. Then they are to introduce anything else they feel would enhance their composition or overall image. They are encouraged to bring into class any visual references they feel would help the process. Examples might include images of gnarled old trees, birds of prey, or other garden equipment.

Students are asked to develop the basic composition in light pencil on the white vellum paper before adding charcoal and black ink to complete the full range of values. The India ink can be diluted if desired.

Student Choices
- imaginary subject matter
- size of paper: 12" x 18" or 18" x 24" or larger
- props/objects used to develop their image
- media (charcoal, ink, chalk, or mixed)

Evaluation
In group critique, ask students which images successfully create a foreboding environment? How was that accomplished? Is a wide range of values employed, from blacks to dark and light grays? How was distortion of subject matter used to enhance the emotion or impact?

Time
Five 45-minute periods: 1 to introduce project and begin compositional sketches, 3 to create image, 1 for discussion and critique

Results and Observations
Due to the tight time frame in class, students were encouraged to develop their compositions at home. Many students choose the 12" x 18" paper size and for time reasons used just charcoal as the medium. Charcoal, by its chalky nature, offers the artist various gray values. Blending shades from light gray to rich blacks creates a range of value. Creating a richly textured and visually engaging garden was a challenge yet offered the opportunity for increased creativity and personal expression.

Conclusion
For students, transforming something that is usually seen as a friendly, even beautiful space into something that is dark or even threatening can pose both a challenge and an opportunity for greater self-expression. As we continue to involve our students' thinking, we need to take greater risks. I was cautioned that the concept behind this studio was too sophisticated for the high school level, and that students would focus on visually grotesque imagery. However, with a clear sense of purpose articulated, safeguards in place warning students against violent imagery, and with a stated emphasis on subtlety, this project was a great overall success.

3-3 Dianna Wojcik
Mysterious elements, contrast, and a strong, flowing composition come together to form a compelling visual image. Charcoal, 18" x 24" (45.7 x 61 cm).

Bold Self-Portraits in Oil Pastels

Inspiration

When we view portrait studies by modern artists such as van Gogh, Matisse, Picasso, or Frida Kahlo, we can see the emotional impact that these artists bring to their work. My goal in this studio was to make a connection between the thinking and emotions of the adolescent and their level of artistic expression. This meant tapping into their psychological knowledge base and encouraging students to draw upon their introspective knowledge to create reflective self-portraits. A donation from a paper mill of a heavy, smooth stock, sized 4' x 8', made it possible for students to work very large, with impressive results.

The nineteenth-century American clergyman Henry Ward Beecher said, "Every artist dips his brush in his own soul, and paints his own nature into his pictures." I think there is truth to the notion that every expressive artwork gives some indication, to the perceptive viewer, of who the artist was when the image was first created.

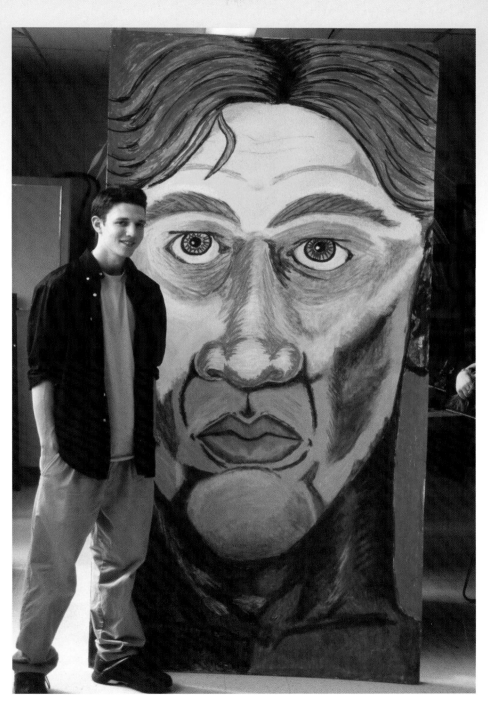

3-4 Jed Singer
Working large contributed greatly to the impact of the student works created.
Oil pastel, 96" x 48" (243.8 x 121.9 cm).

Visual Problem

Students will develop a larger-than-life, bold self-portrait that reflects both their physical qualities and their unique internal psychological structure using the language of art as expression.

Time

Ten 45-minute classes: 1 to introduce the project and generate two lists, 2 for rough draft on newsprint and experimention with color, 7 to create the final image on 4' x 8' white paper

Student Choices

• the degree of symbolic personal exposure in words and in imagery
• use of color

Preactivity

Begin with a general discussion about the significance of expression through the use of artistic materials. Remind students that as human beings we are multifaceted and unique in our personalities and perceptions about life. Because of this we have many varied ways of thinking as well as self-expression.

Materials
▶ 18" x 24" newsprint paper
▶ 4' x 8' 100 lb. paper
▶ foam core, 4' x 8' x ¾" (support backing)
▶ 12"-square mirrors (one per student)
▶ oil pastels

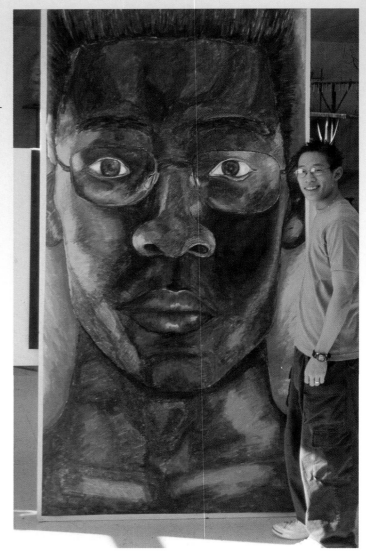

3-5 Mike Cheng
Students understood that really great self-portraits are both expressive and personally revealing.
Oil pastel, 96" x 48" (243.8 x 121.9 cm).

Share that the human mind is very complex and that the experience of adolescence can feel like one is trying to put together puzzle pieces that don't seem to fit together naturally or easily. Complex struggles can ensue as the individual wrestles with significant growth changes both physically and psychologically. Home and family life is another major influence that affects young people in the most dynamic ways.

Explain to students that we, as human beings, have an internal universe locked inside each of us. This is filled with complex feelings, emotions, cognitive thought processes, and spiritual energy. We allow only a small portion of all these personal aspects to come to the surface to be expressed. It is through the expres-

sion and reaction to that expression that we gain understanding about ourselves and others. Artists are among the fortunate few who have creative outlets for their thoughts, feelings, and emotions. Through introspective thinking, reflection, and expression we grow and become the complete people we are intended to be.

For this project, I showed students examples of the stylistic changes seen in the portrait work of Vincent van Gogh throughout his life. I also shared examples of the works of Frida Kahlo, who sometimes expressed both physical and emotional woundedness in her images; Matisse, whose portraits show how color can have emotional impact; and Picasso, whose works likewise offer powerful emotional impact through varied styles. Continue also by sharing expressive contemporary portrait images that you feel will motivate your students (example, works of the American painter Chuck Close).

Process
Part 1
Students begin the initial, cognitive process of this self-portrait study by creating two written lists. The first list will itemize their physical qualities as they look into a mirror. The second list focuses on the more subjective qualities that describe who they are as human beings.

Students begin by listing their own physical characteristics, easily identifiable qualities such as color of eyes, hair, etc. Also included is anything that would be unique to the student, such as wearing glasses, having pierced ears, dark eyes, long or short hair, etc. This is intended as an honest description of how they physically perceive themselves.

Second, students list their personality traits, values, emotional strengths and weakness. This list can be of single words (examples might include "thoughtful," "considerate," "loyal," "angry," "positive," "creative," etc.). Encourage them to allow the adjectives to flow freely, choosing those words that describe and define who they are as a person. This list is confidential and will be shared only to the extent that students apply the information artistically to their work.

Part 2
Having completed these two lists, students are then asked to symbolically translate this written language into expressive artistic language using the elements of art such as line, color, texture, shape, and form. (This is an abstract interpretation, so students are instructed not to use actual symbols such as hearts, flowers, lightning bolts, question marks, etc.) For example, an angry or aggressive personal quality might be represented by bold lines, angular shapes, strong colors, rough textures, etc. A friendly quality might be represented by using rounded forms, soft warm colors, flowing lines, smooth texture. Students are asked: What kinds of lines could represent you? What varied colors, shapes, or textures best describe you? Is only one kind of visual representation in any given area enough to share your unique qualities?

In answering these questions, students are encouraged to think and explore with various types of lines and shapes, with various color densities, as well as with varied textures.

This part of the project can be completed in the students' sketchbook, which will also add a degree of confidentiality to the visual thinking.

Continue by asking students: "What makes a successful self-portrait?" Also: "What do you want to say about yourself that will give the viewer an indication of who you are?"

Part 3
The drawing portion of this studio begins with a light line drawing of a larger-than-life self-portrait. Provide each student with a mirror for use in observing their features and newsprint paper or white vellum for preliminary drawings. The students' image of their head should fill the space and include their neck and collar. Instruct students to be as honest as possible in observing the effect of their image. They are therefore encouraged to exaggerate any aspect or dominant features. This image is not intended

to be a realistic or a fully developed portrait study but a loosely expressive first draft. This image can be used for experimentation with oil pastels before the large final image is begun on the 4' x 8' heavy white paper.

Students begin the final self-portrait on oversize paper using a light pencil line to draw their image as a guideline for subsequent development in oil pastels. Oil pastels by nature are an expressive media, offering fluidity in the expression of line, color, and texture. The image will be a combination of expression connecting how the person looks from the outside as well as including symbolic visual information of how they see themselves on the inside. These two elements coming together on this large paper will create a bold and highly personal self-portrait.

Evaluation

Have students use reflective writing to respond to the following questions. This is not part of the project assessment but simply an occasion to gauge the depth of students' thinking. *Ask students:* How does your image best represent your unique characteristics, both physical and psychological? Which aspect of your portrait is eye-catching, and why? How did you apply your specific knowledge of your personal attributes and qualities to enhance your self-portrait?

Results and Observations

The confidential symbolic visual descriptions first developed in student sketchbooks encouraged the required honesty that was revealed in students' final color images.

The beginning sketch, used experimentally with oil pastels, was a valuable part of the process. Students defined their visual form in pencil, understood the application of the oil pastel media, and began the thinking process by using the language of art to express their personal attributes.

Students worked thoughtfully as they developed their image in personalized color. They utilized some of their chosen colors to unify their image to the background.

The work created on the donated 4' x 8' paper created truly dynamic self-portraits. The students stapled this work onto ¾" foam-core boards, allowing for a lightweight, well-supported, and easily transportable foundation.

Students' reflective writing revealed their thinking process and offered me, as their teacher, valuable insight into how they see themselves as people. This writing was confidential and only made public if they chose to share the information. There were some overall similarities to the meaning students attributed to their color selection. In describing their personal qualities, students used yellow to represent happiness/upbeat thinking, green for life/creativity, blue

for thoughtfulness/determination/shyness/calmness, black to represent aggressiveness/sadness, red for anger/irritability, and complementary colors to represent conflict or contradictions in emotions. These subjective interpretations reflected their thinking and gave richer meaning to their work.

Conclusion

Because we were artists before we became art educators, we realize the importance of our own personal visual expression. I believe this concept is an important one for the high school students we teach. With this in mind, one significant goal in art education is for our students to be offered opportunities that encourage a richer understanding of themselves and outlets for their personal expression. Expression is first based on introspection and reflection, which is then combined with increased skills and understanding of media. This will ultimately lead to greater personal results in student work.

My perceptions about adolescence remained consistent with my previous understanding. Adolescents are in a process of trying to put all the puzzle pieces of their lives together and are therefore filled with divergent feelings. They may feel both secure and insecure, profoundly happy and sad, balanced and unbalanced, all in a relatively short span of time. Their visual work and evaluative writing reflected this thinking.

Their success in tackling this artistic challenge lay in a combination of factors that began with seeing a wide range of portrait examples. Students next reflected on both their physical and psychological attributes by both writing and sketching, then created a bold image. Their final reflective writing offered insight to the student artists about their process. The visual work resulted in impressive and engaging expressive images.

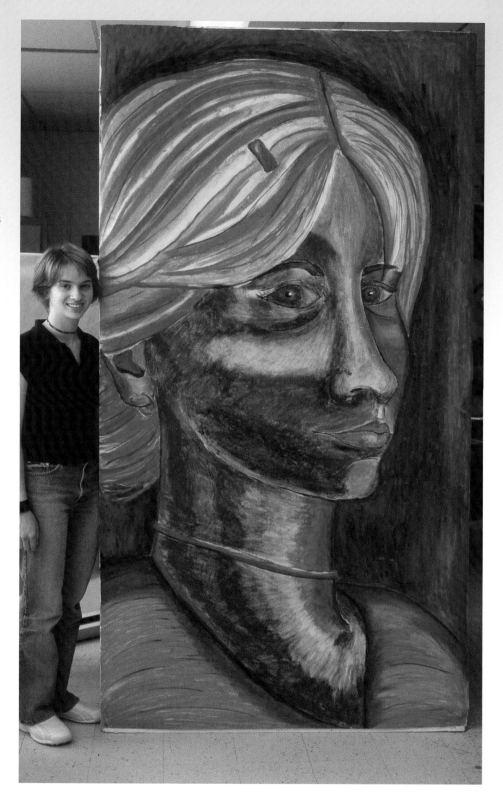

3-6 Abby Scheider
Abby was one of the few students to work using a three-quarters view.
Oil pastel, 96" x 48"
(243.8 x 121.9 cm).

Figurative Clay Sculpture

Inspiration

My motivation for this open-ended figurative project came from a desire to encourage a diversity of personal expression in students' works. Adolescents can offer tremendous insight into their work when given the opportunity to reflect on the images they create, and figurative sculpture offers students the opportunity to think three-dimensionally in connecting ideas to expression. Clay, as a choice of media, is flexible and allows for both additive and subtractive methods of working.

Visual Problem

Students will create a clay sculpture interpreting the human form in an imaginative way that expresses a quality of adolescence.

Time

Ten 45-minute periods: 2 to introduce clay wedging, tools, firing time, daily storage of work, and examples of famous sculptors' work; 7 classes to develop figurative sculpture; 1 for critique and reflective writing

Student Choices

• kind of figure to be developed
• overall size

Process

Share examples of clay sculpture created by varied artists. *Ceramics Monthly* magazine offers excellent examples of both functional and sculptural works of art. Exposure to a variety of artists and their styles offers the student insight into the variety of ways they can approach the human form. Share the work of sculptors such as Auguste Rodin, Alberto Giacometti, and Henry Moore, each of whom offer a varied range of artistic style and expression.

Discuss both additive and subtractive methods of creating sculp-

Materials

▶ water-based clay (Cone 06-temperature 1873 degrees)
▶ a variety of clay tools

ture. Demonstrate wedging clay to eliminate air and scoring clay to create strong bonds, and share knowledge of drying time to avoid cracking. Work should not exceed three-quarters of an inch in thickness. Avoid extreme unevenness in thickness as this will increase cracking and breakage in firing. If working with a mass of clay for subtrac-

3-7 Sylvia Brandt
"This sculpture is a symbol, a feeling of what the world feels like, the wings symbolizing endless freedom of the mind and soul."
Ceramic clay, 6½" x 4⅓" (16.5 x 1 cm).

tive sculpture method, allow clay to dry to the leather-hard stage before hollowing from the bottom of the piece. Student work will be developed to a size of at least six inches in height, width, or depth.

The work is dried and bisque fired before critique. Have students place their sculpture in front of themselves, then introduce them to the reflective writing conclusion to this process. Ask students to look at their work and respond to the following question: "How does your sculpture express a quality of adolescence?" It is extremely important to respect confidentiality in the reflective writing process. This written work is not graded, nor is it shared with others without student permission.

Evaluation

Ask students: Does the work engage the viewer as seen through the development of the overall image, originality, and technical skill? Can you see that even small sculptures can have a quality of power? What make the work engaging? What aspects of the classwork as a whole do you think will cause the viewer to want to look at it again?

Using reflective writing, have students respond in a paragraph about their work. Ask: How does your sculpture share a quality about adolescence?

Results and Observations

The breadth and depth found in the individual work was the result of a project structure that encour-

aged expressiveness. The range of solutions, from realism to cartoon forms to pure abstraction, showed this variation.

Sculpture provides opportunities for a greater understanding of space and three-dimensional form. Water-based clay offers flexibility because it is easy to work with and works well with both additive and subtractive methods. Samson clay is a gray clay that fires to a buff color. It has a fine grog that allows for a good amount of detail if desired.

The reflective writing offered rich insight into student's thinking and artistic decisions.

Conclusion

Figurative sculpture on the high school level can produce rich variety if the assignment is structured in such a way to encourage diversity and personal expression. Since we live in a three-dimensional world, translating our thoughts in artistic qualities can provide a rich aesthetic experience.

Recent brain-based research reinforces the importance of cross-referencing and translating three-dimensional information because it increases cognitive learning. Neuronal connections increase as the eye, hands, and mind work together to process the three-dimensional form.

As discussed in the Introduction to this book, the pattern and structure of the brain go through significant changes during adolescence. In the process, the circuitry of the brain becomes more efficient,

3-8 Jesse Kirsch
Tapping into our students' world of transition offers us greater understanding and insight into their feelings and struggles.
Ceramic clay.

according to Jay Giedd of the National Institute of Mental Health. "Teens have the power to determine their own brain development to determine which connections survive and which don't, [by] whether they do art, or music or sports," states Giedd. Knowing this, we as art educators can reinforce the many significant qualities and values found in the arts. We can hope to inspire our students to continue to make those brain connections in their teenage years so as to promote growth during the rest of their lives.

Artistic experiences in sculpture increase awareness and understanding of three-dimensional form. Having adolescents express ideas through figurative sculpture can offer insight into how they think and view the world they are experi-

Student Reflective Statements

"I chose to make my figures alien-like because I wanted them to have a mysterious look to them. They don't quite fit in with human figures. The one with its head held high shows dignity. It still shows pride in who it is. The other 'alien figure' has no pride in itself and is still just 'evolving'. The high one has accepted its differentness and has no sympathy for the still-evolving one. These statues somewhat represent me and my trials as a teenager. As I never felt that I actually fit in, I started out feeling sorry for myself. But eventually I had accepted who I was and now show the pride in who I am."

—Jesse Kirsch

"My sculpture represents the emotional turmoil that affects the majority of teenagers. It is a time when many people feel trapped and restrained much as the figure I created is. Teenagers are no longer children, but not yet adults. This means that they have developed a sense of how they desire to live their lives and a sense of how the world should operate, but do not have the power or freedom to put these ideals into action. They are bound by the societal constraints forced on them by school, peers, and their parents much as my figure is bound by straps and a straitjacket. Many teenagers are unfortunate enough to get ensnared by an intense desire for popularity. This usually manifests itself by constraining the teenager into a mainstream conformity. The sudden realization of the ills of human nature, society, the government, school policy, etc., can cause teenagers to transfer their disgust into self-loathing. This can cause teenagers to feel mentally ill as if they belong in a mental institution."

—Sean Keeton

"I'm an adolescent and I made this piece to look like me, hence, it is a sculpture about adolescence. My arms are wrapped around myself, as I'm pretty self-conscious, and I'm wearing the oversized black jacket that's become part of my daily uniform. The sculpture is very demonstrative of the insecurity that seeps into every aspect of my life right now."

—Danielle Burgos

"I made this sculpture because these days teens more than ever feel burdened by the way of life: drugs, violence, and suicide. It's tough to just get through the day. So many, including myself, like to escape into a world of dreams, fantasies, and love. This sculpture is a symbol, a feeling of what that world feels like, the wings symbolizing endless freedom of the mind and soul. It is headless because people often think only with their minds, not their heart. Love plays an immense role in the life of an adolescent and people often forget that."

—Sylvia Brandt

encing. Tapping into our students' world of transition offers us greater understanding and insight into their feelings and struggles. New neural connections in learning can reinforce the understanding and richness of the human expression artists bring to their work.

3-9 Danielle Burgos
"My arms are wrapped around myself, as I'm pretty self-conscious, and I'm wearing the oversized black jacket that's become part of my daily uniform."
Ceramic clay, 8½" x 3" x 2½"
(21.6 x 7.6 x 6.4 cm).

Personally Symbolic Timeline

Inspiration

As art teachers, we have a responsibility to educate our students about art history in an effort to make connections between styles and accomplishments of the past and what our students are doing in class. An understanding of the development of artists and artistic movements can greatly influence our own students' artistic development.

I found that one way to connect students with art history was to display a timeline showing some of the major developments and periods in art over three thousand years. My decision to have students create personal timelines stemmed from my enthusiasm to engage the adolescent mind in reflecting on the experiences of their lives.

Visual Problem

Students will create symbolic timelines representing the major events in their lives. These timelines will be developed using mixed media and will be woven together into a single large wall hanging.

Time

Fifteen 45-minute periods: 9 class periods on the three preliminary projects, 1 for brainstorming and writing down experiences, 3 for completion of the timeline, 2 for weaving, reflective writing, and verbal critique

Student Choices

- media
- altering the thickness of the paper line
- personal symbols used in describing events

3–10 Victoria Jan
Strong use of color and attention to detail work well in this preactivity piece.
Mixed media, 9" x 24" (22.9 x 61 cm).

Materials

- white vellum (5" squares)
- white roll paper for timeline (2" x 50")
- a variety of drawing and painting media
- bamboo poles (6' each)
- jute for lashing
- waxed linen for the individual timelines

Preactivity

Students will develop three symbolic designs on five-inch squares using a variety of media. These are a new symbol for the Olympic Games, a new school mascot, and a personal symbol that represents their personality. The Olympic

image should capture the spirit of the Games, focusing on color and iconography. Students may choose to use humor when designing a new school mascot, creating a cartoon or lighthearted drawing. Students should rely heavily on line, color, texture, and form to create these symbols. The techniques that students will use in this exercise will help them later in the development of their own symbolic timelines.

Process

Students should begin brainstorming for their timeline by listing significant memories of events or experiences in their lives. This is a confidential list, not shared with others, and is based on introspective reflection. Instruct students to list these events in chronological order.

Students are then asked to translate these events into the language of art using line, color, value, texture, and shape to represent their feelings and emotions in relationship to their experiences.

Students are asked not to use recognizable symbols such as hearts, flowers, teardrops, rainbows, etc. Instead, they are encouraged to think broadly and abstractly as they use varied lines, assorted shapes,

3-11 Dianna Wojcik (above left) A close-up section of the timeline strip of paper. Watercolor, colored pencil.

3-12 Meredith Ally (right) Students wove their finished timelines into this large collaborative wall hanging.

3-13 (above) Close-up of paper weaving.

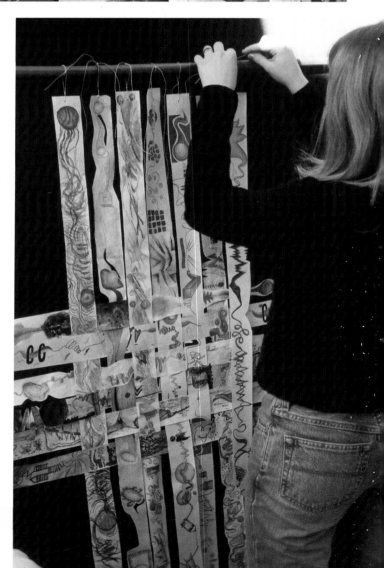

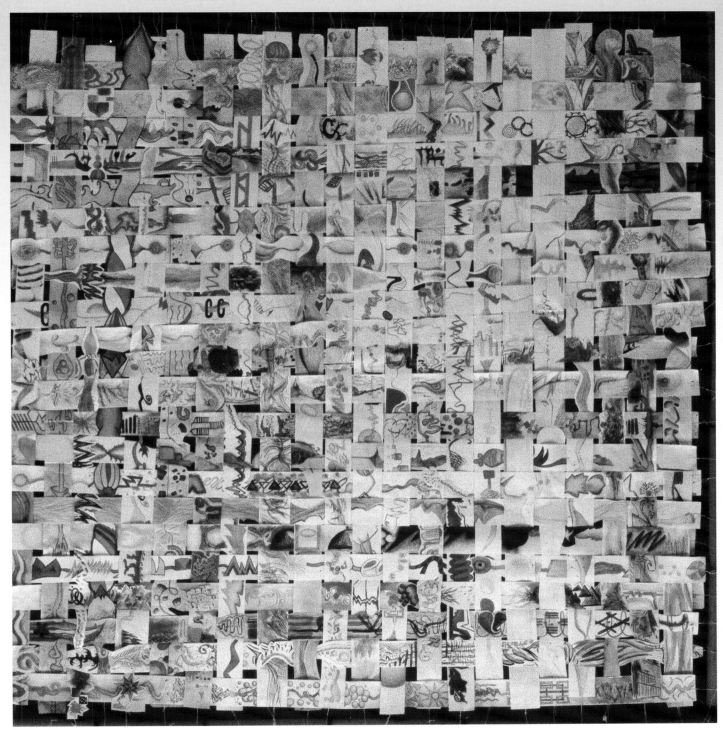

3–14
This completed work reflects the unified image of a community while celebrating each artist's individuality and talent.
Finished paper weaving 6' x 6' (182.9 x 182.9 cm).

Student Reflective Statements

"Thinking up shapes and symbols was hard because developing something to represent a time in my life takes time and concentration. Also, you have to create a higher level of thinking to make it possible."

—Kathleen Renner

"This project has basically taken me on a spiritual journey. This past year has been very hard for me on an emotional level. After having a friend die suddenly and my mom having gone through numerous cancer treatments, I had held in a lot of feelings . . . Doing this project has taught me that it is OK to let my feelings out."

—Lila Symons

"I gained perspective as to how my life has changed in the past few years and how I have changed throughout my life. I found that as I gained more knowledge about the world, the easier it was for me to gain perspective in my own life."

—Arielle Ginsberg

"I realized who I am, as this project helped me to see myself as a whole. Things sort of made sense when I saw the big picture. I also realized what got me here, and how I want to direct certain aspects of my life, because of past decisions and their outcomes."

—Vera Petrovics

"I learned that I am a much stronger person than I once was and that my life has been mostly happy."

—Stefanie Schussel

"Making up new shapes that are not already invented is hard. I wanted to use new shapes that represented my unique life . . . Life and living is a miracle and can't always be represented by simple things."

—Chris Heitz

"I believe of all the work I have done about my life, whether written or drawn, this is the most accurate image I have created. This is so because I was able to use as many media as I wanted and I had complete freedom. I wasn't restricted by words or shape."

—Matt Sikorski

mixed colors, and different textures to create a range of visual language. When each individual's timeline is completed students will weave them together to create a large work of art. This woven tapestry will represent both the community and the individuals who comprise it. The collaboration that occurs during the joining of the timelines is representative of the idea that our lives are woven together through common experience.

Bamboo poles were used to create a six-foot-square frame to hold this weaving. The poles were tied together with hemp string using a simple lashing technique. The poles were carefully measured to ensure that all student timelines would be included in the final collaborative image.

Evaluation

In addressing the first three symbols (Olympic Games insignia, school mascot, personal symbol), ask students to critique originality of idea, use of media, depth of thought, and quality of presentation. For the timeline evaluation, students should consider the degree of preliminary work in sketchbooks, the use of three or more media, overall creative effort, and time spent on task.

Results and Observations

Students felt that emotional content was easier to express in color, texture, and line rather than shape. In the process, most students chose

not to alter or vary the thickness of the 2" strip.

A number of students used this opportunity to ask their parents questions about aspects of their childhood that they were unaware of. This created an unforeseen level of family input that led to further expression in the students' work. The more self-understanding students gained during the course of this studio project, the more comfortable they became with the process.

Using the metaphor that each of us possesses a golden thread of life that runs through our experiences, I stressed our positive similarities as well as the linear aspect of this project. Students' timelines will reflect changes in appearance, as our lives have changed through time. In developing the final image, students are asked to think about and reflect on the development of the timeline and also what surrounds the line in terms of color and texture. Students may choose to leave areas completely white or to fade the color. They can use scissors to alter the shape of this 2" x 50" strip of paper but are encouraged not to go below one inch in width if at all possible.

Many students realized how fortunate their lives had been, even those who had experienced real sadness or tragedy. Encouraging the use of at least three media and not limiting choices was positive and freeing in terms of expression and decision making. This woven collaboration celebrates the uniqueness of the individuals who have come together as a group to create an expressive work of art. In the final evaluation the completed weaving shows a wide range of artistic expression and quality craftsmanship.

This project lent itself quite well to a reflective writing exercise in which students were asked (1) what they felt to be the most difficult part of the process, and why; (2) what they learned about themselves from this project; and (3) to what degree their timeline was an accurate representation of their life, and why.

Conclusion

Before we as artist-teachers can ask adolescents to delve into their personal lives for the purposes of creating visual expression, two safeguards must already be in place. First, a degree of trust between students and teacher must be established. Second, there must be an ironclad understanding that each student's feelings, thinking process, and writing will remain absolutely confidential until such time as the student may choose to share these things with classmates. This is a significant factor in promoting a high degree of honesty as students process complex feelings, experiences, and memories.

Using the language of art as a gateway into introspective thinking can offer the opportunity for thoughtful personal expression, and allowing for student choices in the process encourages even greater freedom of expression. Weaving the individual timelines together as a unit into a single final image reflects the idea that we are a community of people who have artistically come together, and our interwoven timelines exemplify our many common bonds.

Pop Art and the Andy Influence

Inspiration

After visiting the Andy Warhol Museum in Pittsburgh, I became interested in creating a project that explored the phenomenon of the Pop Art movement while having students create a work consisting of multiple images.

Though by necessity Warhol had to rely on screen printing for producing mechanically repeated images, today's students have multiple options for mechanical reproduction of multiple-image works.

3–15 Pana Stamos
This provocative image draws the viewer into the world of the artist who created it.
Colored pencil, paper collage, 10½" x 10¾" (26.7 x 27.3 cm).

Visual Problem

Students will use multiple photocopy-enlarged images of themselves to explore and express their personalities as they further explore the phenomenon of Pop Art.

Time

Sixteen 45-minute periods: 1 to introduce studio lesson, 14 for image development, 1 for critique

Student Choices

- uses of media, including digital media
- overall size

Preactivity

Take a headshot of each student and develop or output each image prior to introducing the project. Label a 10" x 13" envelope with each student's name, then place the student's photo in the envelope to avoid students' seeing them prior to the introduction of the project.

Introduce students to the work of Andy Warhol, and explain his role in the Pop Art movement.

Process

This process was introduced with a little theatrics as the theme of *Mission: Impossible* was being played and a brown sealed envelope was placed before each student. I explained to students that

Materials

▶ film or digital camera, for making one photograph of each student
▶ use of a photocopy machine
▶ 10" x 13" or larger brown envelopes with metal clasp
▶ varied collage materials
▶ varied drawing and painting media
▶ illustration board for mounting the images

when I was in high school *Mission: Impossible* was a weekly TV show. I used the music to create a sense of suspense. Tell students: "Your mission is to fully expose the diverse personality of the image of the person whose photo is enclosed in your envelope."

Students had forgotten about the photo taken weeks before this introduction. After opening the envelope and realizing the photo was of themselves, they were instructed to begin by enlarging this photo using a photocopy machine. They would need six to eight black-and-white copies before actually starting the studio process.

During the first class, I asked the students to use their sketchbooks to list qualities of their personalities and transcribe those into the language of art (line, shape, color, etc.). These artistic qualities can be used to transform the photocopied portrait into an expressive image. Students should develop their photocopies into at least three varied and expressive self-portrait studies using varied media such as tissue

3-16 Lila Symons
This beautiful collage created using handmade paper was a catalyst for identifying the artist's internal feelings. Tissue paper, handmade paper, watercolor, 12" x 11" (30.5 x 27.9 cm).

paper, watercolor, acrylic paint, markers, India ink, metallic markers, etc.

The basic beginning size will be 8½" x 11", as it relates to the size of the photocopy image. Students can work larger by mounting the photocopy onto illustration board. This is accomplished by applying a thin layer of watered-down white glue to the illustration board.

The overall aim of this project is for the students to see a positive quality of developing multiple

images while varying self-expression, and to understand the impact of the Pop Art movement in our culture. Through developing multiple images, students are encouraged to be greater risk takers as they reveal varied aspects of their personality.

The goal is for students to submit three images, from the six or eight developed, to be presented side by side, that reveal the varied aspects of their personality. The use of a series will show the influence and expressive nature seen in the

Student Reflective Statements

"The picture of the destroyed house represents this particularly chaotic time in my home life. My old-fashioned, yet perfect coloring reflects my calm attitude, but like the facade of the 1950s, nothing is truly calm beneath. This is further accented by the illusion of broken glass that the tracing paper provides."

–Pana Stamos

"The colors I chose to use directly reflect my personality. The background red and black represent the depression and anger I can have some days. The cool blues and greens seen in my face and shirt represent the easygoing and helpful attitude I have all the time."

–Steve Adams

"I wanted to portray a feeling of mystery and alienation, so I covered my portrait with hand-made paper to symbolize cloth. I then began to expose myself again by painting tints across my face. The use of purple, integrated into the piece, symbolizes melancholy, which represents my depression."

–Lila Symons

"This image reflects my multifaceted personality. The use of different textures for the eyes and mouth from the rest indicates the occasional inconsistency between my deeds and my beliefs. The different textures also reflect my disinterestedness on many issues and ability to support opposing sides."

–Xun Li

3-17 Steve Adams
Strong contrasts in color suggest the complex personality of the student who created this image.
Acrylic paint, 12" x 10½" (30.5 x 26.7 cm).

repeated work of Andy Warhol. By enhancing photocopy images, students will understand how personal expression varies with the use of transparent and opaque media. Through the additional use of color and line, the use of media will both hide and redefine the structure of the face. Surface texture will also increase or alter the form. Students were asked to significantly change or alter the photocopy so that the viewer would not just dismiss it as a photocopy with media added.

Students are also encouraged to scan the image into a computer if available and use programs such as PhotoShop and Paint Shop to develop an image outside of class. Class time will be completely devoted to the development of varied media and personal expression.

Evaluation

Ask students to respond in reflective writing to the following questions. How does your image reflect your personality? What impact does the creation of multiple images have on the artist and the viewer? Which images of yours are successful and why?

Results and Observations

By creating multiple images, students realize they can afford to make mistakes and that the image is not so precious that it must interfere with real learning taking place. During the process students were reminded that their results were not just media interpretations but reflections of the various aspects of their personalities.

Encouraging intuitive learning came about by continually motivating students to work on more than one image at a time. By responding to each piece and moving to the next, students established an ongoing communication between themselves and their artwork. Emphasized is the importance of that continuing communication between the artist and his or her work.

When I first conceived of the reflective writing component for this studio, I had asked: "How does your use of media reflect your personality?" That soon was reworded to: "How does your image reflect your personality." The first question was changed because answers focused too much on media and

3-18 Xun Li
Applying digital media skills, this student manipulated his original image into a very symbolic personal statement. Computer-generated image, 16" x 9½" (40.6 x 24.1 cm).

not enough on introspective learning. It is important to choose words wisely when framing out reflective questions. It can make all the difference in terms of the depth of student responses.

Student reflection on these self-portrait images provides insight into how the students see themselves and their degree of willingness to share those qualities with the larger community. One reflection I consistently noticed was that many images addressed the extremes of adolescence combined in one image. An example would be seen in the use of color. The color blue frequently was used to represent sadness or depression and was counterbalanced by yellow, which represented the ever hopeful or happy side of

the adolescent personality. A number of students saw themselves as having two distinct personalities, one positive and the other negative, or one side extremely happy and the other profoundly sad.

Conclusion

Familiarity with Warhol's multiple screen prints gave students insight into the expressive use of color and the impact that repeated images can have on the viewer.

This project was based on the premise that we as human beings are multifaceted. Creating multiple images offers the artist motivation to be experimental and not worry if one image does not work out to satisfaction.

Personalized Pen Portraits

Inspiration

On a recent trip to England, I was fortunate to find a collection of attractive bronze pen nibs in an antique store. The box indicated they were manufactured by C. Brandauer and Company Ltd, from Birmingham.

I decided to ask my students to create a functional pen from natural materials, using a nib as a jumping-off point. This newly created pen would be well crafted and artistically expressive.

Upon completion of this pen, I would ask my students to create a self-portrait using the pen. Eventually, students would incorporate a personal written statement about themselves into their visual image. The overall aim is for visual unity in both the creation of the pen and the creative self-portrait image integrating text.

3-19 Xun Li
Tooled copper leaves add to the organic quality of the pen structure. Natural branch, copper, beads, 14" x 7" x 2½" (35.6 x 17.8 x 6.4 cm).

Visual Problem

Students will create an artistic, utilitarian pen using a form from nature as a jumping-off point. They will then use their pens to develop a self-portrait that integrates a personal text statement into their visual image.

Student Choices

- materials
- personal statement and means of integration into self-portrait

Start-up Activity

Ask students to collect something from nature that can be comfortably fit into the hand. Make it clear that the surface texture of the selected natural object will be altered through the subsequent studio process. Possible materials mentioned for this process were tree branches, hedges, bamboo, and shells. At this point the students are

unaware of the exact direction this project is headed, and this adds to their interest at the introduction stage.

Share with students a variety of expressive portraits, both historical and contemporary. This will help students to understand the variety of ways in which they can develop portraiture.

Process
Part 1: Creating a Unique Pen
On the first day, a few teacher examples may be shared with the students as motivation. This shows the potential use of the varied materials and how they can be joined together. This should also emphasize the overall design elements that show visual unity.

Students proceed by thinking and making decisions about the materials they plan to use in the creation of their personalized pen. On the first day, students are instructed to draw ideas about the design in their sketchbooks while identifying the variety of materials they wish to use. They are also to consider that the process they are about to begin is like sculpture in that it can be both additive and subtractive. Parts can be removed from their selected piece of nature or varied media may be added.

Through a variety of artistic media provided, students will experiment to understand the properties of bending, cutting, folding, and manipulating the materials. Students will understand that visual unity in design, color, and materials is

3–20 Julie Baker
Beads were strung through the hollow center of this branch. Natural branch, wire, beads, 12" x 3" x 3" (30.5 x 7.6 x 7.6 cm).

achieved by repetition of those aspects.

Students are also asked to bring in any materials from home that they feel might add to the creation of their pen. Large mailing envelopes that measure 10" x 13" are provided for daily storage of the varied materials being used.

When the pen handles are complete, students will do three things to attach their pen nib. First, students will use either five-minute epoxy or Duco cement to adhere the nib. A clothespin is used as a clamp during the drying time. Second, students are given an 18" length of waxed linen. This is used to bind the nib to the handle. It is wrapped tightly and carefully before being knotted on the underside of the metal nib.

The third step is to wipe a small amount of white glue or carpenter's glue over the waxed linen to bind the linen to the pen handle. The overall look should be neat and clean as well as strong.

Through this entire process students are reminded that the overall emphases in design are to show visual unity through repetition of varied elements and color. Original thinking, personal expression, and craftsmanship are also stressed.

Process
Part 2: Self–portrait
As source ideas for how they may wish to approach creation of their self-portrait, students will have been offered a variety of examples of portraits and self-portraits.

Students began their own self-portrait drawing using pencil on an 12" x 18" sheet of white vellum drawing paper. They will use 2H and HB pencils to produce a light drawing of their reflected image. Twelve-inch mirrors are used for the study aspect of this process. They were asked to focus in detail on one of their eyes and to fade the rest of their image into the background. This is done to focus the viewer on a significant area of the composition. Students are also encouraged to include one of their hands as part of this composition. They are shown examples of many famous portraits which include hands, as they are an expressive aspect of the human form.

Students will continue to develop this image using their unique pen.

A variety of pen and ink techniques such as hatching, crosshatching, and weighted line are explained before the image is begun.

To personalize this self-portrait, a specific text will be included in the visual image. During the beginning of the drawing process students are asked the question "What would you say is true about you today that you believe will be true about you in ten years?" They are given time to reflect on this idea and to write their responses in their sketchbook. There may be many valid responses to the question, so students are encouraged to generate a list as an excellent way to reflect.

Students begin the drawing stage with a light line drawing of themselves. When the light line drawing is complete the personally reflective statement is then thoughtfully placed into the composition. Text can be placed in the foreground, middle, or background. This can also be seen as textural writing integrated into the form as shading or contour, or placed boldly across the image. Explain that the text in the image can be both readable as well as textural. Since a number of my students speak a second language, they were given permission to code more personal statements in that other language. The text statement will be an integral part of their self-portrait and is added thoughtfully as it is placed into the overall composition. Students then proceed to

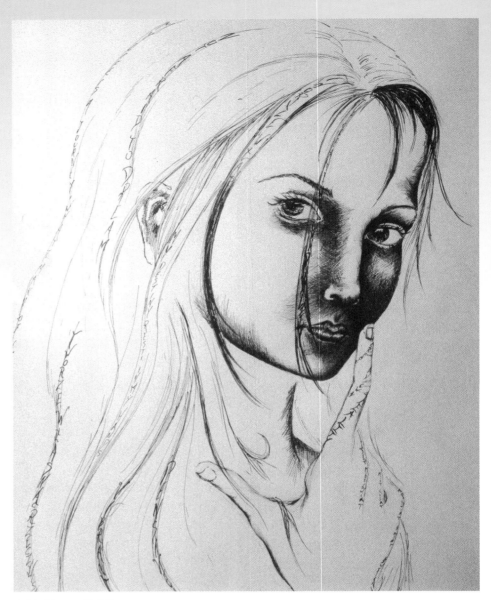

3-21 Dianna Wojcik
Rich contrast brings greater attention to this self-portait.
Pen and ink, 23" x 18" (58.4 x 45.7 cm).

develop their completed image using black ink and the pen they personally created.

Evaluation
Ask students: How have you effected change on the surface of the natural form used to create your pen? What aspects of your pen design shows visual unity? What design elements are repeated? What makes your pen personalized? How well directed is the viewer's eye as it moves over your composition? How

Materials

- pen nibs (one per student), steel or bronze
- object from nature such as bamboo, tree branches, hedge branches, etc.
- a variety of craft materials such as fine wire (16 or 18 gauge), feathers, beads, copper foil, colored thread, straight pins, etc.
- a variety of tools such as: scissors, X-Acto knives, wire cutters, compasses, pliers, clothespins etc.
- large mailing envelopes (10" x 13") for the daily storage of student work
- 12"-square mirrors (one per student)
- 12" x 18" white vellum
- 23" x 18" white 100 lb. hard-pressed paper
- white glue or carpenter's glue
- 2H and HB pencils
- Duco cement or 5-min. epoxy
- India ink
- waxed linen

well did you integrate your personal text statement? To what degree is it seen as text or as texture?

Time

Part 1

Nine 45-minute periods: 1 to introduce the pen design project, 3 to experiment with a variety of materials, 4 to develop the pen, 1 for student presentation and class critique

Part 2

Eleven 45-minute periods: 1 to introduce self-portrait project and to

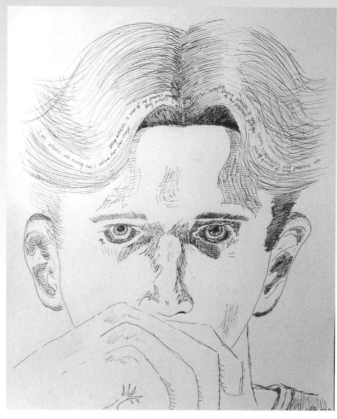

3-22 Jed Singer
The placement of the hand draws the viewer to the intensity of the eyes. Pen and ink, 23" x 18" (58.4 x 45.7 cm).

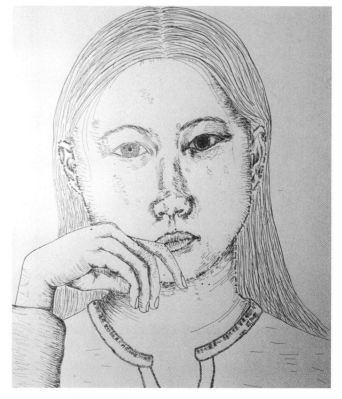

3-23 Wei Ouyang
The text is a selective blending of two languages this student speaks. Pen and ink, 23" x 18" (58.4 x 45.7 cm).

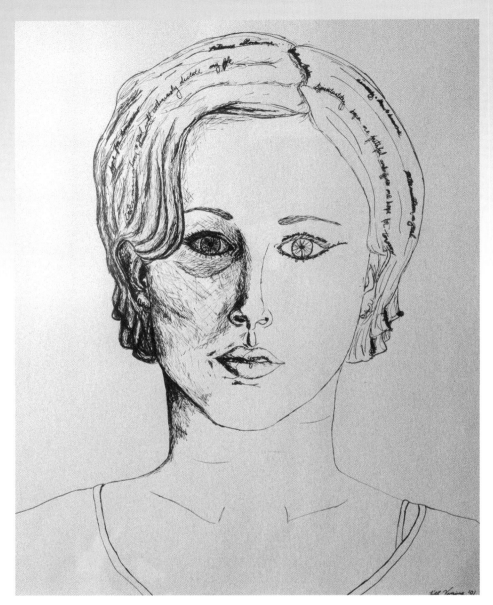

3-24 Jill Vanzino
Jill's decision on the thoughtful placement of text within the portrait is an important element to this project.
Pen and ink, 23" x 18" (58.4 x 45.7 cm).

share examples of portraiture, 4 to develop a light line drawing and record personal thoughts, 5 to develop pen and ink image, 1 for student presentation and class critique

Results and Observations
The results of the pen design project are seen in the students' focus on unified design and craftsmanship in the use of materials. The portraits are evaluated in terms of visual focus, use of grays, and integration of text.

Students learned that green wood branches are easier to carve because they are less brittle. They also understood that the simplest of materials can create a functional tool for artistic purposes.

Another result was that both the pen and portrait were seen as personal statements. Each was developed with personal expression.

In creating their integrated text, students incorporated a number of languages, including Polish, French, Chinese, Hebrew, and Spanish, in conjunction with English, which was expected to be at least part of the text component.

Conclusion

The varied forms of nature chosen by the students offered endless possibilities and solutions for the creative development of a personalized artist's tool. Students were challenged by the process of creating a drawing implement and applied the tool to both writing and drawing in their image.

The personal text statement added a thoughtful level to this visual portrait. The concept of both creating appropriate text and then applying it compositionally was a challenge at first yet proved to be a unifying factor in the overall project.

When the structure of an activity focuses on creative problem solving, students are given the opportunity to take risks, learn how to use varied materials, and produce personally expressive results. The success of this studio experience is seen in the quality and divergent results produced.

What Is True About You Today That Will Still Be True in Ten Years?

"I create my own reality, am not afraid to dream, as my life is a journey."

— Dianna Wojcik

"The rewards of wealth still await those wise enough to see our common pulse. Extend your awareness outward, beyond the self of body, and embrace the transcendent goals of society."

—Xun Li

"My faith in God will never waver. It will only get stronger, and I will keep Him close to my heart. Creativity will always be a part of me."

—Julie Baker

"Being artistic is one of my greatest strengths. I am an athletic and exciting person. Being generous and sympathetic are enduring qualities of mine."

—Jed Singer

"Science, art, and music will always be a part of my life. Pride in being Chinese is part of my identity. I apply my creativity frequently in life."

—Wei Ouyang

"Compassion, honesty, and patience allow me to express myself and let others have a chance. Sincerity allows me to understand myself and others. Determination and zeal will continuously dictate my life. Spirituality keeps me faithful and gives me hope for tomorrow."

—Jill Vanzino

Katy Hu
Oil pastel, 26" x 40" (66 x 101.6 cm).

Personalized Art History

This chapter includes innovative projects that provide meaningful connections to art history via exploring various artists' styles. At the same time, the studios facilitate the making of artistic connections that will increase students' skill level and visual awareness. The art history connections presented here promote both consideration of notable artists and exploration of their styles, as students apply their newfound knowledge in seeking new avenues of personal expression.

One important thing to keep in mind: In teaching history-related projects such as these, I have found that students most benefit when the historical reference is made at the optimum time in the lesson, whether it be at the beginning, in the middle, or at the end. As a result, students can place their newfound knowledge into a tangible context. Rote memorization places information in our short-term memory, where it is easily replaced or forgotten. Contextual learning, on the other hand, enhances the connection we as human beings need to remember information.

In my growth as an artist-teacher I have learned to appreciate the dynamic history of art. In turn, I have sought to develop exciting ways to make art history come alive for my students. The following studio experiences are structured as investigations of visual problems that chart a path to exciting learning via successful classroom art making.

Symbolic Personal Expression and Kandinsky

Inspiration

After considering the diversity of personalities among the students I teach, I wondered how this quality could be expressed in a collective art project. How can we as teachers explore the qualities of the individuals we teach, as we broaden their understanding in using the language of art for expression?

The work of Wassily Kandinsky provided inspiration for this studio—in particular his painting titled Succession, *viewed in the Phillips Collection, Washington D.C., which integrates a symbolic reflection of that artist's passion for music. I started to think about a cooperative group project that would involve all of my classes. I eventually conceived of a project that began with student introspection about themselves, followed by symbolic visual interpretation, and ending in a series of expressive artistic statements joined together to form a compelling composite.*

Visual Problem

Students will create a small-scale, focused artistic image that symbolically represents their personal human qualities. Students will discover how they can use the language of art to make a visual

4–1 Sarah Leu
This start-up-activity painting of organic form shows a successful use of mixed color while maintaining visual interest.
Watercolor, 12" x 18" (30.5 x 45.7 cm).

connection from their own personal expression to the style of Kandinsky, eventually creating a unique composite work in the spirit of the Russian artist's *Succession.*

Time

Fourteen 45-min. periods: 4 for geometric shape project, 5 for organic shape project, 4 for symbolic image project, and 1 for mounting of composite work and final critique

Student Choices

- composition and color selection in all paintings
- collaborative placement of final images on the "musical staff"

Start-up Activity

Before they were to begin the expressive painting project, I wanted to be sure the students had a foundation in painting techniques. I asked students to develop two watercolor paintings, one using geometric shape and the other

reflecting an organic form. Developed in a small, 6" square to focus visual interest, the geometric image would allow practice in color mixing and application of personalized color. For the subject of the organic painting, students observed green bell peppers, which offer consistency of shape yet uniquely different forms. I instructed students to first create a line drawing showing at least one whole pepper form as well as at least one cut in half. This image should fill the page and appear to run off all sides.

Students were then given basic information about the color wheel and use of analogous colors, color ranges, and mixing. Their experimentation with mixing color included changing the density of the medium while working on the bell pepper images. Students had the option of using fine-line black markers to enhance the final form.

Process
After the geometric and organic painting experiences were complete, students moved to the expressive/symbolic process. They began by creating a list in their sketchbooks of at least ten adjectives that described and defined who they are as a person. The list was done in the first five minutes of class and for the most part was confidential because students were asked to share only one descriptive word with the rest of the group. During this sharing time, students were given the option to add another person's descriptive word to their list if they felt it applied to them. The list need not be limited to ten.

Working on the same page of their sketchbook where their list was recorded, students were asked to translate symbolically this written language into artistic language using the qualities of line, color, texture, form, or shape. The use of symbolic representation required that students avoid using literal images of hearts, flowers, lightning bolts, question marks, etc.

For this exercise, I provided students with some examples to consider: An angry or aggressive personal quality might be represented by bold lines, angular shapes, strong colors, rough textures, etc. A friendly quality might be represented by use of rounded forms, soft warm colors,

4-2 Chris Heitz
A 6"-square design led up to the personal symbolic design.
Watercolor, pen and ink, 6" x 6"
(15.2 x 15.2 cm); and 2" x 5" (5.1 x 12.7 cm).

4-3 Zeven Rosser
This subtle and carefully articulated miniature painting symbolically represents the student's personal qualities. Watercolor, pen and ink, 3" x 5" (7.6 x 12.7 cm).

flowing lines, or smooth textures. Students were asked: "What kinds of lines would represent you? What varied colors, shapes, or textures best describe you? Is only one kind of visual representation in any given area enough to share your unique qualities? Reflecting on the creation of visual representations for each of their chosen words, students began to define themselves in artistic language.

Having completed this exercise, students were encouraged to work on large white vellum paper, combining, overlapping, repeating, and incorporating their chosen artistic language into design of a single visual symbol representative of their human qualities. They did not know at this point that they would eventually be asked to reduce this information to the space of a 3" x 5" card. As students developed their image, they were asked: "Does your image best represent your unique characteristics?"

Because my aim was to allow students to develop their work prior to introducing the stylistic approaches of Kandinsky into the process, it was at this point in the studio, and not earlier, that the connection to the artist was introduced.

In sharing information on Kandinsky, I explained that he was first influenced by Impressionism but later moved to nonobjective subject matter as he chose to use the language of art in abstract ways. In his development as an artist, he eventually no longer felt that he needed to represent objects but rather should express mood instead. I shared that music was an important source of inspiration in his work, and that he allowed it to facilitate transport of his visual thinking into the world of abstraction. Finally, I shared an image of his painting *Succession,* this studio project's first inspiration and the format of which the final group composite image would echo.

Next, students were instructed to reduce the image from their sketchbooks to a 3" x 5" unlined white note card, and then to cut out the image using scissors or X-Acto knives. During this time, I prepared a large sheet of white vellum for the class, painting a series of thin horizontal bars. These observe the basic layout of Kandinsky's *Succession.* The painting employs a unifying grid of such bars, suggestive of a musical staff, on which the artist has aligned rows of colorful floating abstract shapes. The final step is the students' placement of their individual personalized images onto the large sheet for final presentation. Care is given to the placement of the student work, with primary consideration given to color and spatial relationships. The final visual result included at least one image from each student in the class.

Evaluation

Have students respond via reflective writing, in complete sentences and paragraphs, to the following questions: "How does your image best symbolically represent your human qualities?" "Explain specifically how your use of line, color, texture, form, and shape describe or define you."

Results and Observations

The start-up activity was a good lead-in for varied use of shape, color, line, texture, and overall use of media. For the organic painting, a collection of peppers of varied shapes and sizes worked well, as students developed personalized mixed color and learned how to best utilize the watercolor media. They benefited from observing and representing the peppers' varied forms, both exterior and interior. Students were encouraged to enlarge the form when drawing. The geometric painting offered a

4-4 This composite image created by 23 students reflects Kandinsky's concern for musical themes. Watercolor, pen and ink, 22" x 30" (55.9 x 76.2 cm).

focus on creating a small composition that maintained visual interest and offered additional mixed-color opportunities through the use of watercolor.

In the final symbolic work, the students created varied personal images that reflected insight into the uniqueness of their human qualities. The class composite image reflected the styles of the individual student artists while paying homage to Kandinsky.

Reflective writing on the part of the students added to the richness of the learning experience. The writing component was not graded, yet served the dual purpose of providing an assessment opportunity and a chance for students to consider what they had learned in this studio process.

Conclusion

This was a project in which I decided to join the students in the artistic thought process and to produce an image of my own to go along with each class's work. My own image was placed in the upper left-hand corner of each class's composite. This allowed me to share the studio experience and also take the risk in each class of explaining how and why I chose to define or describe myself in the artistic language selected. I believe my participation made a positive addition to the students' overall experience.

Inclusion of every student's work in the composite image reflected the rich diversity of their personalities. When students' final symbolic images were placed with their classmates' on the horizontal grid, each group of students succeeded in realizing a satisfying connection, across time and culture, from their own personality and choices to the abstract musical expression of Kandinsky.

Christo and Jeanne-Claude Wrapped and Unwrapped

Inspiration

Visitors to Washington, D.C., may recall the visually attractive scaffolding made of aluminum and heavy-duty gray-blue netting that enveloped the Washington Monument during its renovation in the years 1997–2000. This translucent membrane covering, the design for which was credited to the architect Michael Graves, was to protect visitors as the repair work was being done. When I viewed it at the time, I realized the thoughtful visual covering created for this renovation had a visual impact very similar to that of the large-scale wrapped works of Bulgarian-born artist Christo and his partner, Jeanne-Claude.

This studio experience, inspired by the work of Christo and Jeanne-Claude, aims to increase students' awareness of these artists' style and to engage students in an understanding of how three-dimensional structures can be visually changed in form.

4–5 Sean Keeton
Focused observational drawing led to successful representation of the subject.
Graphite pencil, 12" x 18" (30.5 x 45.7 cm).

4–6 Sean Keeton
Bold and personalized color work well to create this striking image.
Colored pencil, 12" x 18" (30.5 x 45.7 cm).

Materials

▶ household objects/tools
▶ white sheeting for wrapping
▶ section of rope (clothesline)
▶ 12" x 18" white vellum paper
▶ drawing pencils (2H through 6B)
▶ colored pencils or watercolors
▶ tracing paper

Visual Problem

Students will view an assortment of varied pre-wrapped objects, select one, and create two drawings of this chosen form. Students will develop a value study in which the first half of the first pencil drawing is of the unknown object in its wrapped state, the second half is in its revealed state. A second image, developed in mixed color will show the qualities of the visually combined form.

Time

Twenty-two 45-minute periods: 1 period to introduce the project and begin contour line of overall shape, 12 to develop the value study that includes the wrapped and unwrapped hand-tool image, 9 to develop the final image in color

Student Choices

• which object to draw
• deciding to do two complete value images (one wrapped, the other unwrapped) before beginning the combination
• how to creatively combine images
• media and mixing of color

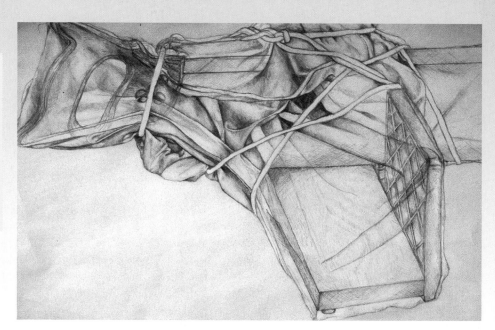

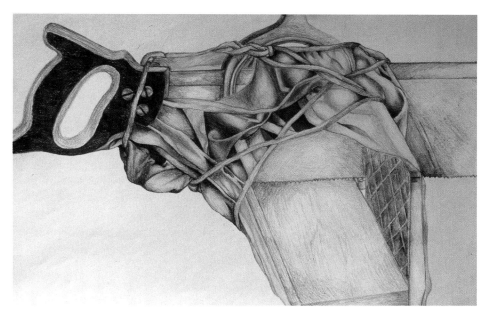

4–7 Mike Cheng
The first image is a pencil drawing of the unknown object in its wrapped state.
Graphite pencil, 12" x 18" (30.5 x 45.7 cm).
4–8 Mike Cheng
The second image, developed in mixed color, combines images of the wrapped and unwrapped form.
Colored pencil, 12" x 18" (30.5 x 45.7 cm).

Christo and Jeanne-Claude Wrapped and Unwrapped **79**

Start-up Activity

Share the work of Christo and Jeanne-Claude and the dynamic sculptural qualities that have emerged from their use of scale. Talk about these artists' early attraction to wrapped objects and specifically how form changes and becomes visually altered when it is covered. See how mysterious the form is in the wrapped state as the viewer tries to discern the contents of the package. Have students notice the relatively simple materials that Christo and Jeanne-Claude use to create their bold works.

These artists use a variety of hand tools to accomplish their creations. I too decided to utilize hand tools, but in this case as the wrapped subjects of this project. The tools chosen were an electric drill, electric circular sander, electric jigsaw, large wooden clamps, crosscut hand saw with miter box, electric circular saw, and electric vibrating sander. These objects were pre-wrapped in white cotton sheet material using clothesline. The subjects to be drawn are disguised within these packages so that their contents are not revealed.

The element of surprise adds to the excitement of this project, so it is important that the wrapped forms not be handled by students. Each form is placed on a sheet of 18" x 24" black paper in the middle of each drawing table. This offers visual contrast but also establishes an imaginary boundary. The students are asked not to handle the objects.

Students will use a variety of drawing pencils. Explain that "H" pencils reflect the hardness of the graphite and will produce light gray lines. "B, 2B, 4B, 6B" pencils use graphite that gets softer as the numbers get higher, producing rich dark grays to black. All work needs to be accomplished using very sharp pencils.

Process

Students are to walk around the room and decide which object they find most visually appealing to draw. Their first drawing begins in light line, which can start as a contour yet will evolve into a full value study in one focused area. This image should compositionally fill the 12" x 18" white vellum paper.

Students begin this light contour line drawing using an H or 2H pencil. This drawing will include the contour of all edges, including the folds and clothesline. They will then continue in one concentrated 5-inch-square area, fully developing the complete value range of that area. This focused area can then fade into the light contour line drawing. When this completed value area is finished, the object is unwrapped. The student continues to draw the revealed object in the same composition. As a result, the wrapping material will naturally look somewhat transparent as the students continue to draw the actual object.

Have students realize that they are to render the image of the object. This is not intended to be a loose sketch but a focused observation. Successful realistic drawings come from close observation using a range of pencils, building up the gray tones while creating contrast. Value study drawings are created through a series of marks, hatching, and crosshatching while utilizing a wide range of drawing pencils. No smudging is permitted, because it detracts from a successful rendering.

The wrapped or unwrapped first image is created in drawing pencils and the second combined image is developed in a choice of blended colored pencils or watercolors. For this color image, students may use tracing paper to capture the essence of the subject matter from their first drawing. Most students held the image up to a window and traced onto a second sheet of vellum paper. As the students progress to the color image, a light line drawing is desirable so that the graphite will not mix into their chosen media.

Encourage students to mix color and be very expressive in order to increase their understanding of how color can be personalized. Students are also instructed to change the density of the media through layering of the media. This will add to the richness of the work, as the forms show solidity and then fade and appear transparent. This concept works particularly well in the folds of material and adds contrast to the subject matter. Visual unity is also stressed. This comes as the students decide on the color scheme and how the varied

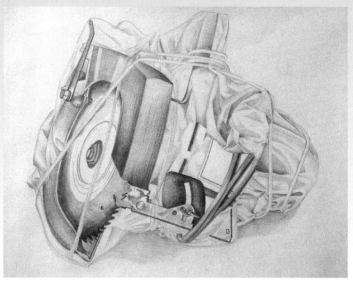

4-9 Jennifer Chen
This drawing effectively uses value contrasts to define the subject form.
Graphite pencil, 12" x 18" (30.5 x 45.7 cm).

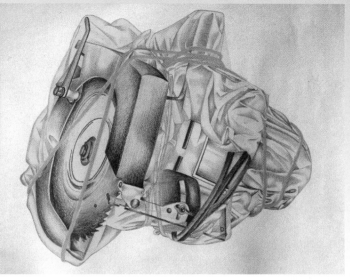

4-10 Jennifer Chen
Colored pencil, 12" x 18" (30.5 x 45.7 cm).

color density will be repeated in this final color image.

Evaluation

Students are evaluated on the quality of the observational drawing, for the degree of value, neatness, and strong composition. The creative combination in the final image is assessed for the use of blended color, balance seen in the wrapped and unwrapped object, and overall visual impact.

Ask students: What was the most difficult aspect of this project? Did *not* knowing the contents of each package make the process more, or less, visually engaging? Can you see how the form can be completely changed by wrapping it with a simple piece of material? Which of your images demands greater attention from the viewer? Why?

Results and Observations

From the start, the wrapped objects had the "Christo" look yet on a miniature scale. The aura of mystery added to the motivation for this highly focused drawing project.

Storing seven wrapped objects on a daily basis was easy, as they were placed on drawing boards and moved to the side of the room between varied classes. Each was marked and placed in the same location each day before class so the students could sit in the same location while not handling the wrapped packages.

Some students were able to figure out the contents of particular wrapped objects, but I did not reveal these to them. I shared my conclusion that the object in its wrapped state was probably more visually interesting and engaging than it was in its unwrapped state.

In unveiling the forms, students experienced an element of surprise. Each finally saw the object they had been drawing for days, but had previously seen only in its visually altered state.

Some students chose to complete two value images, one in the wrapped form and one in the unwrapped form, before combining them into the final color image. They felt it was easier to fully concentrate on the complete drawings, leaving the creative combination till last. In the end, all students

understood that the deadlines they were given remained the same, whether they completed one value study or two before undertaking the combined color image.

Getting students to progress slowly and thoughtfully was a challenge, yet the aim was for a well-articulated image and this could not be done quickly.

Increasing and understanding the use of both value study and mixed color was significant to this learning process.

Conclusion

When this project was first introduced, many of my high school students looked at Christo and Jeanne-Claude's work and asked: "Is this really art?" I no longer feel the need to defend this question. Instead, I lead students into an experience that reveals qualities about the thinking of the artists.

Just as Christo and Jeanne-Claude, in creating their arresting works, intend to provoke reactions from viewers who they hope might see the commonplace in a new perspective, so too did the students' creative imagery engage the viewer. Through this visual problem they gained a greater understanding of how any subject can change form when it is disguised. The resulting work, like Christo and Jeanne-Claude's, was visually engaging as well as striking.

My House Influenced by Piet Mondrian

Inspiration

There is a rhythm in architecture that is seen in the uses of space, the achievement of principles such as balance and pattern, and the repetition of shape, line, color and value, texture, and form. I developed this studio in hopes that students would see those qualities and produce an image of the structure in which they live, based on the repetition of art elements.

I decided to ask students to create a collection of relief house structures that reflected the simplicity and visual interest of Piet Mondrian's abstract paintings. The reliefs would be constructed from a quantity of scrap mat board acquired for the art room in many colors from a local frame shop. In the end, the students' works would be combined to create a cooperatively developed community of structures.

Visual Problem

Students will create and combine two low-level reliefs that identify the structure of the house in which they live, one view from the front of their house and the other view from the back. These relief structures will reflect the approach to design seen in the work of Mondrian. Finally, the reliefs will be combined into a series of large mobile structures.

Time

Fifteen 45-minute periods: 1 to introduce the project and review the homework, 12 to construct the individual units, 2 to critique and hang the mobile structures

Student Choices

- color scheme
- use of organic forms in combination with artificial forms

4-11 Hee Won Shin
The simplicity of form in this relief reflects an awareness of Mondrian's style.
Colored mat board, 12" x 14" x 2"
(30.5 x 35.6 x 5.1 cm).

Materials

- colored mat board
- X-Acto knives/metal rulers
- 10 and 15 lb. nylon fishing line
- no. 1 fishing swivels (one per student)
- 20" wooden dowels (number dependent on size of mobile structures)
- 3/16" steel rods, 3'–5' in length (for top level of mobile)
- foam core
- white glue
- fine sandpaper
- 5-min. epoxy

4-12 Chris Heitz
Visual unity is reflected in this work's use of repeated color.
Colored mat board, 12" x 14" x 2" (30.5 x 35.6 x 5.1 cm).

Start-up Activity

As a homework assignment, ask students to draw their house. Four line drawings will be created, the first a direct view from the front of the building. This drawing identifies the architecture (configuration of the windows, doors, roof, etc.). The second drawing should be from a distance, showing any trees, shrubs, telephone poles, or other objects that overlap the profile of the structure. The exact distance chosen should be up to the student, but a portion of the house structure still needs to be visible beyond any objects in the foreground. The third and fourth drawings will repeat this process using views from the back of the house.

This start-up activity offers the student a chance to consider the form of the designed structure and the organic and geometric forms that interrupt the view of that structure. The type of building a student lives in is not important, only that the student look at the overall configuration of the structure and its relationship to nearby shapes.

Next, share information about the Dutch artist Piet Mondrian (1872–1944), whose paintings, responding to the excitement of the city and designed structures, offer viewers a visual understanding of rhythm. At the height of his career, Mondrian focused on straight-lined geometric shapes, particularly rectangles, using just a few colors in each composition, to produce clean, asymmetrically balanced paintings. The mathematical calculations revealed in these works reflected his love of jazz music.

Process

Students should transpose the linear drawings of the front of their home into the basic shapes seen in their structure. Instruct students to choose a color scheme from the collection of mat boards that utilizes three colors (in echo of Mondrian's frequent use of just three colors) and to cut the mat board for each shape found on the house structure. They should begin by cutting the main shape of the house, front and back, before the smaller shapes for windows and doors are cut. The cut pieces are stored on a daily basis in reusable envelopes until the relief

For best control, students should use X-Acto knives only while standing, employing two to three strokes in the cutting process. A metal straight-edge used as a guide adds to control.

process is started. When the student has completed cutting the front shapes, the process is repeated for the back of the house. Having chosen three colors for the front, students may wish to select a different three colors for the back, since the viewer will only see one side at a time.

A relief will be developed on one side using the various shapes found on the front of the house, and on the reverse side using the shapes found on the back of the house.

Small cut pieces of foam core may be used beneath the relief sections to create a dimension of height on a variety of levels. White glue is the bonding agent best used with the mat board and foam core. The two-directional reliefs will, in essence, form a three-dimensional structure. The color white seen on the edge of the mat board and the foam core will naturally be seen by the viewer, from the side.

The overall size of each relief is limited to 14" in height or width yet no deeper than 3½". This relatively small size serves to focus the viewer's attention and also to ensure that no one structure will dominate another when the works are assembled as a collection. The challenge is to focus on the simple shapes reflected in the original drawing, using placement of shapes

and repetition of color to create a rhythm.

Students' use of spatial relationships in the design need not be slavishly consistent with the precise shapes or colors of their houses. Things like shutters, drain gutters, or outside lights can be eliminated and rectangular shapes squared if so desired.

Craftsmanship and clean presentation are particularly important in this studio experience. Edges of mat board and foam-core board must be smooth. Fine sandpaper may be required for the purpose of creating smooth edges. Any pencil lines should eventually be erased, and no glue should show in the final presentation.

A final goal of this project is for students to collaborate in connecting the collection of houses through

4-13 Rishi Roongta
Because the final works were to be combined in suspended mobiles, students were asked to develop both the front and the back of their house in relief.
Colored mat board, 9" x 13" x 3"
(22.9 x 33 x 7.6 cm)

4-14 The school's media center provided a safe and accessible exhibition space for the mobiles.

the development of large mobiles. This final stage will result in a community of artistic house structures floating in space. Each student's work will be hung from 10 lb. nylon fishing line from the wooden dowels and 15 lb. nylon line hung from the long steel rods. A brass fishing swivel is attached at the end of each dowel and the metal rod so that the forms may float easily. After the placement of each fishing swivel, five-minute epoxy is used to secure the swivel from falling off.

Evaluation

Ask students: Does your work evoke Piet Mondrian's use of space, rhythm,

and balance? How has the visual form of your house changed through this process? What kind of balance does the geometry of your structure show?

Results and Observations

My students live in many different types of homes—everything from apartments in houses and large buildings to townhouses to extremely large single-family homes. To bring equality to the overall design aspect of this project the size of the finished work was intentionally limited to 14" in any direction. Most individual structures resulted in 3½" or less in depth, which seemed to

work best proportionally in relationship to the width and height proportions.

Students did show some frustration with creating clean edges on both the mat board and foam-core board. The one sure way to achieve excellent results is to always use a very sharp X-Acto knife. Blades will need to be replaced frequently if a large number of students are using them.

As students worked through the process, they were given the option to use geometric shapes to represent shrubs and trees. The majority felt the project was complicated enough, and most chose only to focus on the architectural elements of the house.

Through the process, students understood that Mondrian simplified form and color to create clean design. The students' created houses reflected the simplified geometric qualities seen in this artist's work. I did feel several works might have

benefited from a more simplified, abstract approach. On the other hand, instructions to that effect might have resulted in oversimplification of design for the sake of expediency, in which case students would have missed the opportunity to fully describe the structure in which they live.

For creating the mobiles, 10-pound nylon fishing line was attached to the top of each house structure through a strip of foam core glued between the two mat board reliefs. For balance, two holes were used so that when threaded with nylon thread a triangle was created. This was more workable in achieving a balanced hanging than trying to find the single, exact point from which to hang the overall structure.

Conclusion

The large mobiles created by students reflected a pleasing variety of relief styles. These beautifully

balanced forms, floated from the ceiling of the school's media center, captured the simplified design used by Mondrian yet evoked the visual integrity of the students' real and unique homes.

Notably, introduction of the Mondrian reference after the students made their initial drawings but before they started work on the reliefs led to an active and productive experience. One satisfying result of this studio was that in developing their own compositions, students succeeded in exhibiting an understanding of the artist's style in the context of applying the historical reference. As a consequence, experience of this personalized project, making a definite connection with Mondrian, promoted fuller student understanding of style in art history and of how such knowledge can be applied in a creative studio investigation.

Reflection on Richard Diebenkorn

Inspiration

After viewing an exhibition of the remarkable paintings of American artist Richard Diebenkorn, I decided that my high school students might benefit from an exploration of his expressive style, particularly as seen in his abstract landscape images. My hope was to teach about abstract expression by offering students a tangible studio experience related to this contemporary artist's work.

An untitled 25" x 19" painting from 1980 in gouache, pastel, and ink on paper had left me thinking about its relationship to the rest of Diebenkorn's body of

4-15 Katy Hu
Blended and subjective use of color helped to personalize this final image.
Oil pastel, 26" x 40" (66 x 101.6 cm).

work. The painting, whose imagery includes a seven of spades, appeared at first glance to be a deviation from the artist's more formal work. Yet in this mixed-media work one could see some of the same compositional strategies to be found in his better-known landscapes. Realizing that in the coming semester I would be teaching three classes totaling roughly 52 students on the advanced level, I toyed with the idea of challenging students to create an artistic deck of cards. Perhaps 52 abstract playing-card images, each incorporating the image of a different card from the 52-card deck?

As I refined the approach I would encourage in students' exploration of this artist, I eventually abandoned the playing-cards conceit. Instead, I determined to ask students to make connection to abstract expression using a more personally meaningful subject matter as the jumping-off point.

Materials
- 12" x 18" white vellum
- pencils, fine-line markers
- 26" x 40" heavy white drawing paper
- a variety of drawing and painting materials (oil pastels, acrylic paint, felt tip markers, pen and ink, collage, mixed media)

Visual Problem

Students will create a personally meaningful large color image that investigates the uses of color and perspective while exploring the abstract compositional technique of Richard Diebenkorn.

Time

Twenty-one 45-minute periods: 1 for the mini–field trip around the school property, 6 for the first drawing of the overall school property, 3 for the second drawing of the actual building, 10 for development of final image, 1 for critique

Student Choices

- degree of abstraction of the subject
- subject to be developed in final image
- media for final image

Start-up Activity

I began by asking students a series of questions through which they might begin to reflect on the uses of abstraction in two-dimensional art. For example: "Have you ever wandered into a gallery or museum and asked yourself how a certain abstract painting was conceived?" "How does an artist's choice of physical perspective on a subject affect the type of image that is created?"

Before the work of Diebenkorn is introduced, we reviewed the concept of the figure-ground relationship and how it functions in the readable format of traditional two-dimensional works. This format includes a foreground, middle ground, and background, with the subject established through the use of perspective established by placement of a vanishing point on the horizon to create the illusion of depth. Traditional perspective offers the viewer a logical understanding of the subject's spatial relationship to the viewer. Next, ask students, "What would a landscape look like if you changed that traditional perspective, so that the viewer is looking straight down on the subject from a bird's-eye view?" "What would happen to the depth of field and the relationships of forms to one another?"

Before beginning the drawing phase of the studio, I took each class on a mini–field trip outside to walk the perimeter of the school property. I asked students to imagine that they were in a hot-air balloon or a helicopter looking down on this landscape and to consider what the school building and property, including the parking lots and playing fields, would look like from this perspective. Students were encouraged but not required to take notes or make sketches during the walk for use in development of the subsequent drawing.

Process

Next, students were asked to make three line drawings. The first was an approximate bird's-eye view of the school property, the second a homework assignment representing a similar view of the place where they live, and the third a visual geometric expression of the high school building in which they spend their weekdays.

The drawing of the school property, in light pencil on 18" x 24" white vellum, would define the human-made as well as the organic shapes (such as trees and scrubs) that they saw while walking the perimeter of the school property. The proportions of this image were to fill the paper completely. After sketching the initial contours of the subject, students proceeded using a fine-line marker or ballpoint to include as much detail as they could remember in developing this drawing. Proportions were important, yet this was not intended to be an architectural drawing.

In the corresponding homework assignment, students were to draw their home and the immediate area in which they live from the same bird's-eye perspective they used for the drawing of the school buildings and grounds. This was accomplished in their sketchbooks by using fine-line marker or ballpoint pen.

When the first image of the school property was finished in class, students began a second drawing. This one looked at either the actual school building or, again, at the overall school property. This time, however, students were to feel free to exaggerate the importance of certain areas of the actual building in order to emphasize the subject classrooms or areas of the facility they related to the most. Thus, some areas might increase in

View of the layout of the school grounds.
Pencil and felt-tip marker, 18" x 24"
(45.7 x 61 cm).

4-17 Maureen Jackson
Each student's interpretation of the subject
and sense of proportion differed.
Pencil and felt-tip marker, 18" x 24"
(45.7 x 61 cm).

4-18 Sarah Cruser
Thoughtful use of mixed color and visual texture in media work well to create a unified image. Mixed media, 26" x 40" (66 x 101.6 cm).

size while others would need to be reduced. For example, a sports enthusiast might enlarge the size of the gym or a specific playing field. Students might increase the size of the cafeteria or even add the location of their locker if they choose to. Our school has a senior courtyard, which is a privileged space for seniors, so developing that area was an option for seniors. This conceptual image is also on 18" x 24" white vellum and is created first in pencil and then in fine-line felt-tip marker.

At this point, I introduced the work of Richard Diebenkorn, showing examples of his paintings. I explained his personal artistic transition over the course of his career from figurative to abstract techniques, and I shared examples of

this transition and of influences seen in his work from artists as diverse as Henri Matisse, Piet Mondrian, and Paul Cézanne. (Diebenkorn uses the flat pattern and bold colors of Matisse, the geometric imagery found in Mondrian, and the subtle distortions in the picture plane evident in Cézanne's work.)

I showed how Diebenkorn's later landscapes, such as the Ocean Park series, employ a flat, bird's-eye perspective to depict physical environments. With their bold colors and distortions of space, these landscape works are highly expressive. Through their geometric play of lines and angles, the images nonetheless capture a specific power of place.

Examples of student class work is shared with the group to see if students can see similar compositional similarities between their work and that of Diebenkorn. It is at this point that I introduce the visual problem—how to create a personally meaningful large color image that investigates the uses of color and perspective in the style of Diebenkorn's abstract compositional technique.

Students selected a single image from their three drawing compositions for use in developing the final image on 26" x 40" heavy white drawing paper (100 lb.). Students were encouraged to exaggerate or distort significant elements by using the color or size of an object in the interest of expressive possibility.

4-19 Sean Keeton
The bold linear quality seen in this painting reflects Diebenkorn's style.
Acrylic paint, 26" x 40" (66 x 101.6 cm).

Evaluation

Ask students: How does your final image employ form, color, and perspective to suggest a landscape from a bird's-eye view? How does your image reflect the essence of Richard Diebenkorn's style? Has your view of the areas you see every day changed since you began this project? If so, how? What have you learned about abstraction as it applies to landscape?

Results and Observations

Some students learned more about the layout and forms of the school property than they had ever imagined possible—many having spent up to four years on the premises without really ever taking the time to carefully observe it.

The second, distorted image students created evolved quite well to reflect the compositional strength and visual abstraction of Diebenkorn; in fact, this project might have been successfully concluded with the second school image. However, having been fortunate to have acquired the 26" x 40" vellum paper, I wanted students, once they had been introduced to Diebenkorn's work, to have the opportunity to work at the large scale.

Daily storage for 50 some pieces from the three classes who undertook this studio experience required a little creativity. Two 50' clotheslines were attached from the art room ceiling and the students used clothespins to hang the work. Students could observe the progress of each other's compositions; for some, this provided the motivation to do their very best work.

Students used a wide variety of media, from oil pastels to acrylic paint to mixed media. Some students drew upon Diebenkorn's technique of washing multiple color layers, allowing for some colors to show through.

Students realized that abstraction can be a useful approach to personal expression, though what is clear and readable to the artist may be somewhat opaque to the viewer.

Conclusion

This visual problem focused on students' greater awareness of their surroundings, the use of varied media to develop their work in

4-20 Zeven Rosser
This highly distorted and expressive image is reflective of the student's bird's-eye view of the school environment.
Mixed media, 26" x 40" (66 x 101.6 cm).

abstract expressionism, and a richer understanding of a notable American artist.

The project taught that by viewing your surroundings, both at school and at home, from a new perspective, one's perception of reality changes and increases overall awareness of spatial relationships. In terms of abstraction and expression, students realized that no two images were the same even if they had the same starting point. Said one student, "I have learned that expression can be representing an ordinary subject in a unique way to create meaning."

This work led to an increase in knowledge about the power of a specific place as it is used to construct an image for abstraction. Personal artistic expression came with a greater understanding of abstract expressionism.

A David Hockney–Inspired Still Life

Inspiration

I began with a question: "Is it possible to motivate students to develop a still life that can show a response to an established artist's work while going beyond this to explore the varied use of expressive line?" David Hockney's drawing Panama Hat *(1972) groups its subject along with a striped jacket and a clear glass placed on a bentwood chair. Hockney's strong contrast and composition are the attraction.*

4-21 Lila Symons
This work employs a wide range of value.
Pencil, 18" x 24" (45.7 x 61 cm).

Materials

- 12" x 18" or 18" x 24" white 80 lb. drawing paper
- colored pencils
- a range of drawing pencils, 2H, H, F, B, 2B, 4B, and 5B
- Black drawing pens, sizes 0.3mm, 0.5 mm, 0.7mm

4-22 Amanda Biddle
The weighted line used here works well for its expressive qualities.
Pencil and ink, 18" x 24" (45.7 x 61 cm).

Visual Problem

Students will explore the use of varied line and see its influence on a subject. Students will develop three line drawings of a single still life from three perspectives using contour line, weighted line (lines of different thicknesses), and expressive line.

Time

Eleven 45-minute periods: 2 for contour line drawing, 3 for weighted line drawing, 5 for expressive line drawing, 1 for final critique

Student Choices

- the visual perspective for each still-life drawing
- size of drawing paper (third drawing)
- kind of expressive line in the third drawing
- pencil or pen in the third drawing

Start-up Activity

I began by setting up a still life that evoked the basic arrangement of Hockney's *Panama Hat,* with the art tables placed in a circle surrounding the chair with hat, glass, and jacket. I placed a sheet of 12" x 18" white drawing paper in each work area and gave each student a single colored pencil. Students were instructed to draw the still life from their particular perspective for a given time period of 30 seconds to two minutes, at which time they were told to stop and, taking their colored pencil with them, to move to the seat of the person to their right. The goal was to have each student add their color to the collaborative image. Through this process the students move completely around the circle of tables, ending at the work space where they began. This activity offers students the opportunity to view, record elements of, and therefore visually understand the make-up of the entire still life in one class period. I followed this activity by initiating a short general review discussion on approaches to composition and expressiveness, trying to elicit at least one comment from every student so that no one individual felt singled out.

At this point, I shared examples

of David Hockney's work, including *Panama Hat,* explaining that Hockney is a British artist who is internationally known for his drawing, painting, and set design.

Process

Students began by selecting an area of the still life to draw in modified contour line. They were instructed to draw only when their eyes were on the subject, stopping as necessary when they wanted to check their image.

The work was created first using a No. 2 pencil or its equivalent (B or 2B drawing pencil). When the pencil drawing was complete, students used a black technical pen to go over the initial drawing. They were instructed that the quality of line should be continuous and flowing.

The second drawing was more difficult, as students learned to vary their lines. Creating line that changes in thickness or from light gray to rich black begins with an understanding of light source and how that impacts the subject. Lighted gray lines are placed to show the strongest light and the darkest are the ones in the most shadowed. This drawing was completed in pencil using a range of drawing pencils.

Before the third and final expressive line drawing was begun, I shared several more successful examples of expressive line, so that students could gain a broader sense of the visual possibilities of working in

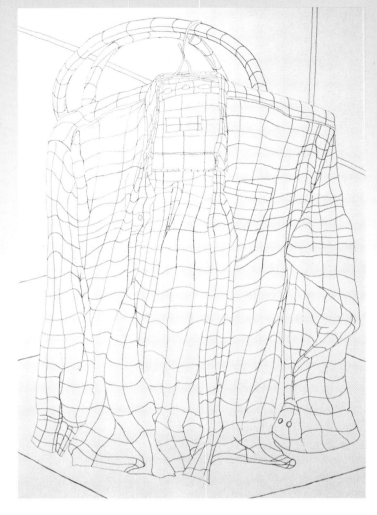

4-23 Zeven Rosser
This final image has the liveliness of a freestanding wire sculpture.
Black felt tip marker, 18" x 24" (45.7 x 61 cm).

line. These included a drypoint work by Picasso entitled *Head of a Woman* (1933; Metropolitan Museum of Art), which shows how overlapping circular lines can create visual rhythm and contrast, and a van Gogh drawing in brown ink and black chalk, *Portrait of Joseph Roulin* (1888; J. Paul Getty Museum), which uses hatching and crosshatching to achieve value contrast. These images planted the idea that each of us can use line uniquely to create an expressive image.

There were no limitations to the third drawing in this series other than that it stay within the boundary of using only line. Pencils or technical pens were available for the students to choose from.

Evaluation

Ask students: When looking at the varied styles seen in the class's drawings, is the kind of linear expression easily identified? Is personal expression exhibited? Does the work reflect strong composition while maintaining visual interest?

Results and Observations

Exploration of the varied uses of line increased students' visual awareness, eye-hand coordination, and knowledge of composition. Use of a strong light source for the weighted line drawing helped students to see the relevance of using this type of line. In the course of our ongoing discussions, the students considered the uses of both positive and negative space in developing their compositions.

Conclusion

This simple still life offered an engaging image as well as a connection with artists David Hockney, Picasso, and van Gogh. The opening cooperative exercise gave the students a sense of freedom to choose from varied perspectives and to change that perspective in the course of the three assigned drawings. A final exhibit in the high school media center elicited many positive comments from students and faculty alike.

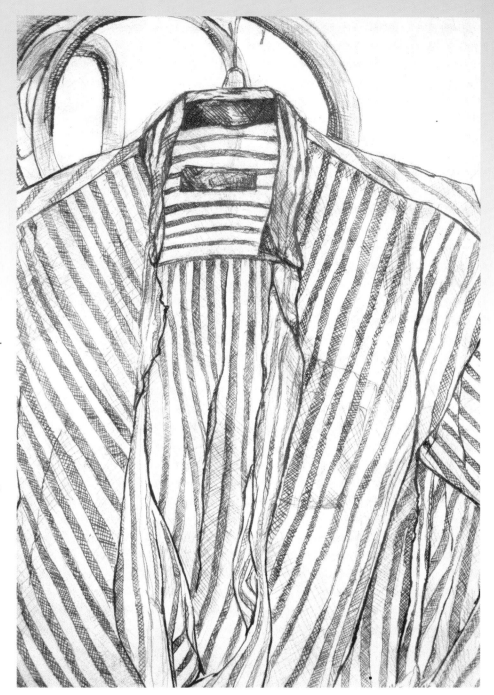

4-24 Mike Cheng
Strong composition and use of contour line create success in this work.
Black felt-tip marker, 18" x 24" (45.7 x 61 cm).

Revisiting the Famous Rhino

Inspiration

This project was inspired by the artistic styles of two master artists from different eras: the sixteenth-century engraver Albrecht Dürer and the twentieth-century Surrealist René Magritte, both of whose work shows attention to detail and a high degree of ingenuity. My interest was to explore their stylistic influence to motivate the creative thinking and personal expression of my three classes of advanced-level students.

Dürer's images are well recognized for their detail, texture, and touch of fantasy. Magritte offers the viewer alterations of form and texture in recognizable forms while reflecting dreamlike fantasy.

An additional motivation for this project was the children's book Seven Blind Mice *by Ed Young, a Caldecott Honor Book whose text and images show how our perceptions of reality change as we piece together bits of information to understand a larger picture.*

Visual Problem

Students will use Dürer's *Rhinoceros* woodcut as a starting point for an investigation of texture that employs the alterational devices of Surrealism to create a unique imaginative land-

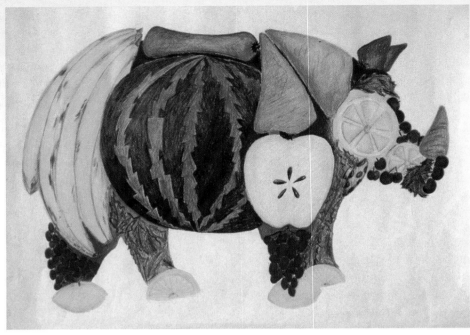

4–25 Victoria Jan
Colored pencil, 18" x 24" (45.7 x 61 cm).

scape within the recognizable contour shape of the famous rhino.

Time

Fifteen 45-minute periods: 1 for introduction, 13 for idea development, 1 for critique and evaluation

Student Choices

• choice of subject development
• media

Start-up Activity

As a series of homework assignments, I asked students to draw

objects and then alter their original texture to something unexpected. Students began with a human hand, an isolated area of a plant structure, and three other natural (not human-made) objects of their choice. They studied the actual texture of the object being drawn, then they drew the object with new, simulated textures that were different from those of the original object. For example, if the object was smooth and soft, students challenged the viewer's perception of the object by exploring alternative textures such

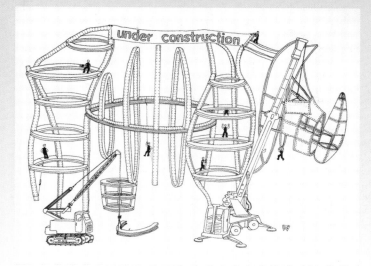

4-26 William Rohrbach
Black felt-tip marker, 18" x 24" (45.7 x 60.9 cm).

4-27 Jesse Kirsch
Graphite pencil, 18" x 24" (45.7 x 60.9 cm).

as rough, hard, glassy, fuzzy, bumpy, coarse, spiky, spongy, wrinkly, etc.

In preparation for the studio, I made a series of enlarged transparencies of six or seven segments from a print of Dürer's *Rhinoceros,* enlarging each segment to 8½" x 11" in order to highlight the print's textures. These segments would then be used to motivate the students' imagination while asking them to think about what it might be that they were looking at.

Next, I enlarged a photocopied image of the rhino and traced the contour of its shape onto 18" x 24" tracing paper. The enlarged image of the actual rhino measured 14" x 20". I cut out the shape using an

X-Acto knife. This cutout would later be used by students as a template to create a uniform size and shape for their final images, though the content of their subjects would vary greatly.

At this point in the studio, as a class, we read and discussed the children's book *Seven Blind Mice* by Ed Young. An unusual activity for a high school art studio, yes, but it was a fun place to begin, and in time students would see the story's relevance to the project at hand. The picture book offered a commendable example of graphic design in addition to varied examples of texture and an element of surprise that would support the project.

Next, and before introducing the full image of Dürer's *Rhinoceros,* I showed the series of transparencies in which the viewer sees only parts of the whole. Students were encouraged to discuss what they saw when they viewed these abstracted

images. To motivate creative thinking, I asked students what they saw, and, using their imaginations (with the lessons of the children's book we'd read fresh in mind), what they thought the images could become.

The last transparency shown, the full view of Dürer's rhino, as was also true of the last image of the children's book, revealed the complete subject developed creatively by the artist. (I explained that Dürer never actually saw this animal. He created his woodcut from a sketch and written description made by another individual.) Students were then shown the work of Magritte, in particular, images that change the subject into stone. Examples included *Recollection of Travels* (1950), *Recollection of Travels III* (1951), and *The Castle in the Pyrenees* (1959). Students were encouraged to see how this artist challenges viewers' preconceived ideas about materials and form.

Attention was then given to

4-28 Pana Stamos
Graphite pencil, 18" x 24" (45.7 x 60.9 cm).

students' texture homework assignments and their relevance to experimenting in texture and Surrealism. Students were encouraged to consider the attention to detail evident both in their own works and those of the two master artists.

Process

As students turned to creating their own imaginary new landscape using the rhino template I provided as a jumping-off point, they were instructed to use sketchbooks for preliminary planning. They sketched the basic outlines of the rhino for use in working out their subject and overall composition. Once all major decisions had been made, they were ready to undertake the enlarged final version working on the 18" x 24" vellum paper.

After tracing the oak tag template to the paper, students referenced the full image of Dürer's rhino in order to work out the basic shape divisions they would use within the larger shape. These guidelines helped to structure students' ideas in relationship to the basic form.

Students were reminded that they were to create a new textural landscape on the subject of their choice while reflecting the stylistic tenets of Surrealism. Attention to detail seen in the students' imaginative imagery was stressed as they worked through the process.

Students selected the media they felt worked best for their subject. They also had the choice to work in black and white or in color. Students who chose to work in color were reminded to blend and mix color in order to personalize it, and to consider use of repeated color to create visual unity.

Evaluation

Ask students: Does your image show attention to detail, strong textures, and imagination? Can the viewer identify the thematic quality you were hoping to achieve? What aspects of your work help to create visual unity?

Results and Observations

This project increased students' textural awareness and understanding of how textures can be applied. The use of surprise, as exemplified in Ed Young's *Seven Blind Mice,* where the image of an element is revealed at the finale, provided motivation for students to devise their own strategies for creating an unexpected visual effect.

Brainstorming ideas and settling on one was a challenge for students, but once a subject was chosen, many students did research

4-29 Meredith Alley
Colored pencil,
18" x 24"
(45.7 x 61 cm).

in the media center to support the information they needed for their chosen subject matter.

The structure of this project inspired creative diversity in the results. Students produced varied textures and explored many thematic subjects (including fruit, vegetables, building structures, maps, flowers, animals, fish, armor, landscapes, and technology), with only a few students from the three art classes who undertook this studio approaching the rhino using the same theme.

During the critique, students in each of the three art classes were asked to select three images that they felt were strongest. Each winning selection was given the "Golden Rhino Award for Excellence" and exhibited in the media center with a 3" x 5" reflective gold foil award indicating the artist's name and grade. Student response to this simple acknowledgment of achievement was surprisingly positive.

Conclusion

Creativity can be inspired and exercised as we propose challanges that help students make connections in their understanding of visual complexities—in this case those between the use of applied texture, concepts of Surrealism, and personal imagination.

The students' inventive images showed attention to detail, as they were asked to work within the readable format of the rhino shape. This offered the students a clear visual problem-solving structure that challenged their creativity and engaged their imagination while promoting the development of observational skills.

Sean Keeton
Colored pencil, 18" x 24" (45.7 x 61 cm)

Providing Rich Diversity for Your Art Program

Previous chapters in this book have been organized around studio experiences that explore the principles of design, the use of everyday materials in art making, avenues for personal expression, and style in art history. In the interest of promoting artistic inquiry that risks making larger, real-life connections, whether to aspects of character, community, culture, or history, the studios in this chapter employ a range of jumping-off points. These include thought-provoking subjects ranging from career opportunities in the art field to women's achievement, the culture of Japan, community service, health issues, and character education. The chance to consider such subjects gives students further opportunity to integrate the development of art skills with exercises in higher-order and critical thinking.

I believe that pursuing the kinds of studio approaches outlined in the following pages can uniquely position students for success in both understanding the world and creating images that demand to be seen. By doing so, students learn to challenge the viewer, themselves, and each other, both to look and to think.

Artistic Business Cards

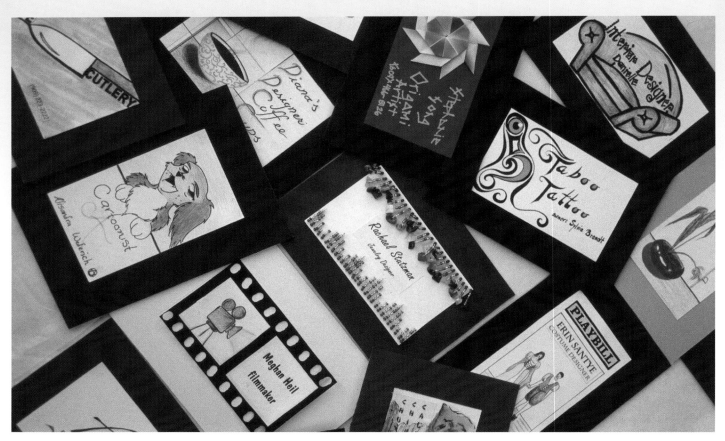

Inspiration

Today's students with a strong interest in art have an almost unlimited number of options for making a career in art and design. Further, exposure to a range of art careers—from graphic design to architecture, teaching, and fashion, product, and environmental design—can promote constructive thinking and motivation in young adults. Whether or not any of your students are considering an art-related career, their familiarity with the world of professional artists and designers, and the importance of their work to everyday life and culture, can provide basic credibility and direction to their study of art. In my desire to increase students' understanding of the many varied career opportunities in the visual arts, I decided to develop a design project focusing on diverse and innovative approaches to creative business cards.

5-1 This collection of business cards suggests the range of thinking that went into this successful project.

Visual Problem

Students will design three personalized and varied business cards that advertise potential careers in the field of art.

Time

Six 45-minute classes: 1 to introduce, 4 to develop the final project, 1 for critique

Student Choices

- careers to advertise
- media

Process

I began by leading an open-ended discussion on careers in the visual arts, making frequent reference to a large poster that shared a variety of careers.* Next, I shared resources on graphic design for communications. The purpose of this early discussion was, first, to expose students to the full spectrum of

Materials

- ▶ pen and ink
- ▶ felt-tip markers
- ▶ watercolor paint and brushes
- ▶ colored pencils
- ▶ various collage materials
- ▶ heavyweight white vellum paper
- ▶ rubber cement
- ▶ white glue
- ▶ assorted colored mat board

*Chapter 12, "Careers," in Hobbs, Salome, and Vieth, *The Visual Experience,* Third Edition (Davis, 2005), pp. 326–49, provides a useful overview of art-related careers. For more in-depth information, see Brommer and Gatto, *Careers in Art* (Davis, 1999), and *Art Careers! Talks with Working Professionals,* 6 vols. (Davis Art Video, 2001).

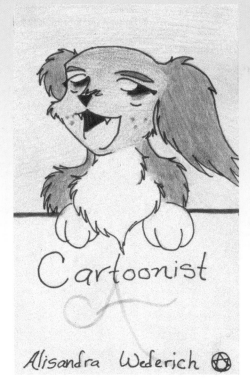

5-2 Alisandra Wederich
Combining eye-catching image with direct text is a formula for success.
Colored pencil, 5" x 3" (12.7 x 7.6 cm).

professional artistic opportunities; and, second, to provide a starting point for the design project students would be undertaking.

Students were instructed that the designs created needed to be visually striking, readable, and appropriate to the career choice. The students could decide the composition, subject for design, and media of the three cards. Each business card would include the name of the chosen career and the student's name as the "owner" of the occupation represented. Students could use computer-generated copy for the text portion of the card, but the card itself was to be designed in traditional media.

Students were given a single sheet of heavyweight white vellum paper (8½" x 11") to measure and cut for the card design. The 3" x 5" designs could be developed in any media and when complete would be mounted for presentation on 5" x 7" mat board. All three images created were eventually mounted on colored mat board with a 1" border. In the end, presentation was important; the work needed to be neat and clean with no adhesives showing.

Evaluation

Ask students: Are the designs of your three business cards readable and unified? Does the craftsmanship show that you were careful in all aspects in your use of media? Do your images demand to be seen? Are they striking?

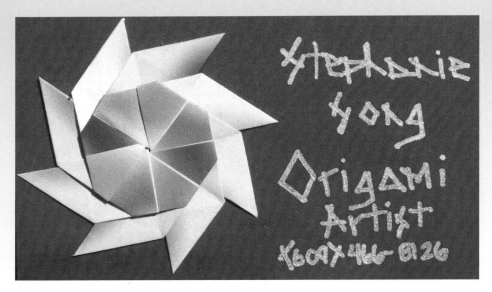

5-3 Stephanie Song
A low-relief 3-D quality added to the effectiveness of this business card.
Folded paper, pen, 5" x 3" (12.7 x 7.6 cm).

Results and Observations

Students quickly realized the variety of possible directions in which an artist might extend his or her creative and design talents. It was difficult for some students to limit their choices of careers to just three. Many students spent additional time outside of the allotted class time to achieve their quality results.

Students understood the value of working in a small and very focused way. They realized that attention to detail and craftsmanship are important as they understood that the results created, in their application of the elements and principles of design, were like small works of art.

Conclusion

I believe that increasing high school students' awareness of career opportunities helps to break down the stereotype that students who go into the art field will become "starving artists." This project increased student awareness of careers and the many varied ways people can put their artistic talents to work. It also increased students' understanding of the importance of advertising design.

An important resource for me in thinking about this project was a book called *The Best Business Card Design* (Rockport, 1997). A quick Web search indicates that there are a number of books available on this topic, any one of which might serve as a useful resource.

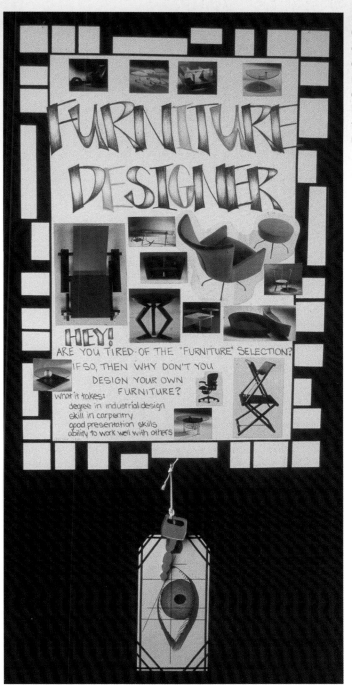

5-4 Jen Chen
One side of this work offers text that describes job requirements for a furniture designer.
Mixed media on illustration board, 10" x 15" (25.4 x 38.1 cm).

Inspiration

Realizing the importance of visual information in modern culture, artists are and will continue to play a major role in communication in the future. This role is facilitated by the rapid growth of new production and design technologies.

Art teachers can play a significant role in creating awareness in students of the skills required for art-related employment opportunities. We do so when we teach the principles of the language of art and the application of the elements and principles to developing strong compositions and focused designs. To be visually literate is to understand these principles and their application to the creation of readable visual images. Additionally, higher-order and critical-thinking skills such as synthesis, analysis, and evaluation are needed to solve visual problems.

This project will involve students in a real-life situation: creation of an advertisement connecting text and image. Readability, clear visual communication, and clarity of design will be stressed.

Visual Problem

Students will create an eye-catching work that increases awareness of job opportunities and/or careers in the art field. The works will be two-sided. One side will include text that defines the skills or education needed for their chosen career opportunity. The other side will use only images to indicate both the skills and attitudes needed to succeed in the chosen career.

Time

Twenty-two 45-minute periods: 1 to introduce the project, 2–3 to research and create preliminary sketches, 10 to develop advertisement (Part 1), 5 to develop visual image (Part 2), 2 to develop identification tag (Part 3), 1 for critique and final presentation

Student Choices

- career opportunity
- media

Preparation

Cut lightweight illustration board to desired size (10" x 15"). A collection of unused keys were sprayed gold for the use in the final presentation.

Materials

- a variety of drawing and painting materials
- lightweight illustration board
- oak tag package mailing tags
- 10 lb. nylon fishing line
- cup hooks for ceiling installation
- old keys/gold spray paint

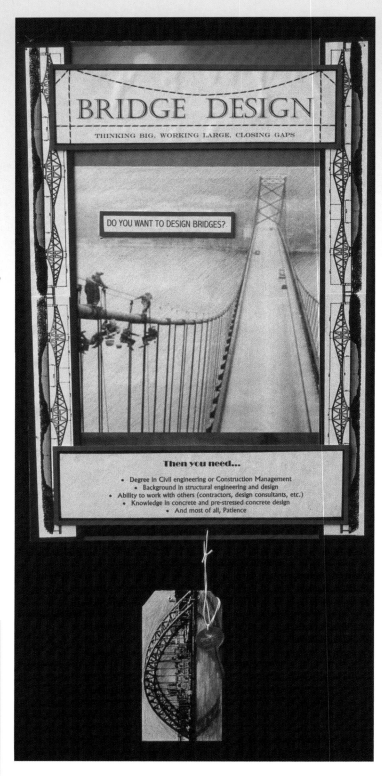

5-5 Mike Cheng
Mixed digital and traditional media, 10" x 15" (25.4 x 38.1 cm).

Process

Provide students with a broad list of art-related careers, and then ask them to consider careers that could be added to this list. Each student will select one career in which to concentrate, including research and development of images to represent that selection. Students should identify specific skills, education, and any other important qualities needed for the specific job, while bringing greater awareness to the career opportunity.

Part 1: Advertisement

Students will begin by developing the first of two images that address a specific career opportunity in the art field. Both images will be 10" x 15" and developed vertically. The first side of this back-to-back image will advertise the career opportunity, explaining the knowledge, skills, and training needed for such a career. The text needs to be readable and should be connected to a strong visual image. Written information will include title of job, description of specific skills, and education needed. This image can be developed in part or completely using any media or mixed media desired, including the computer.

Part 2: Visual Image

The second side of this panel is a visual representation, without words, of each student's chosen career. This is a striking visual that demands attention of the viewer while exemplifying the specific

job/career available. This image too can be developed in any media, traditional or digital.

Part 3: Identification Tag

Suspended and connected to the two-sided image is a shipping tag with a gold key. The key is a metaphor for a key to the future. This is an identification tag of the student artist who created the image and the area of interest in the art field. On one side of the shipping tag is the student's name and the career they chose. On the other side of the shipping tag is an image of a human eye created to be eye-catching to the viewer. This eye is created showing the influence of the career they have chosen. Example: A tattoo artist would create an eye as though it were tattooed, a cartoonist would create the human eye as an exaggerated cartoon form.

These combined images will be suspended from the ceiling at eye level in order to draw observers' attention to the varied opportunities available in the art field. Viewers will be able to manipulate this collection of images to both read and appreciate the varied sides.

This interactive suspended display of work will be exhibited in an area of the school that is accessible to non–art students. At my school, the school media center was the most secure and accessible area to exhibit. The title of the show was "Keys to an Artistic Future" and suspended from each identification tag was a spray-painted key.

5-6 Sylvia Brandt
This work advertises a career in tattoo art.
Mixed media on illustration board,
10" x 15" (25.4 x 38.1 cm).

Evaluation

Ask students: What elements in your image are eye-catching? Why? Is your text clear, readable, and understandable? What invites the viewer to be engaged in your image? Does the work reflect the content of the subject you selected? How was that accomplished? Does your work show visual unity?

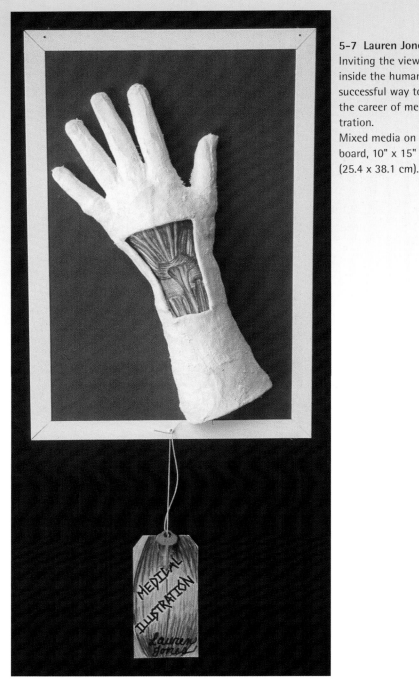

5-7 Lauren Jones
Inviting the viewer to look inside the human form is a successful way to promote the career of medical illustration.
Mixed media on illustration board, 10" x 15" (25.4 x 38.1 cm).

Results and Observations

It was recommended that only two students, at most, select any one career opportunity. This produced greater diversity in the final work. The wide range included landscape designer, medical illustrater, advertising artist, tattoo artist, art educator, set designer, fashion designer, filmmaker, graphic designer, art therapist, furniture designer, photojournalist, greeting card designer, animation artist, and city planner.

Through one-on-one and group discussions, students analyzed their compositions to consider integration of text and subject and overall impact of the developing images. The ongoing critique was helpful for students, as they refined their images in the process.

The progression from advertisement to creative visual image to eye-catching identification tag offered an excellent series of transitions in visual thinking, offering the ability to communicate first using words, then with a strong visual focus on the actual subject, and finally with a small yet striking suspended label. Student decision making on media added to the level of each student's involvement.

The student works were suspended together to create a collaborative grouping whose aim was to engage the viewer as it served to increase awareness of the employment opportunities in the art field. The gold key color conveyed a sense of importance; the uniform size conveyed visual unity to the final collaborative piece.

5-8 The final exhibition, in the school's media center, was an interactive display in which students and visitors were encouraged to walk around and among the images to see both sides of the works.

Locating the exhibit in the media center was an invitation to other students, teachers, and administrators to view student work and see the vast opportunities in the art field. Viewers were impressed by the diversity of opportunity and the students' personal expression.

Conclusion

In approaching ways in which to draw attention to the number of careers in the art field, I was cognizant of the importance of creating a project that was engaging by using both text and graphics to inform others. Yet most of all, I wanted students to be absorbed in the process of creating the visual and to have fun as they represented the elements of a chosen job or career.

I was particularly interested, as this project concluded, in the degree of interest each student showed in their classmates' results. Not only were the art students engaged in each other's work, but the exhibit in the schools media center demanded the attention of a much broader audience.

My aim was to have the school community increase its understanding of careers in the art field and to be able to see the impact of art on the world of commerce and business.

Increased visual literacy comes with what is learned artistically through the process of moving from idea to a product that expresses the idea. The overall process is brought to life through the process of creating, learning, and reflection. Visual literacy reflects the articulation of an idea through the use of artistic materials while applying the skills of the language of art to the final image. My goal of increasing my students' knowledge through this artistic expression was successfully reached.

Remarkable Women of the Last Hundred Years

Inspiration

My initial motivation for this studio came in response to a public television program focusing on the plight of women in India and in the Middle East. The broadcast investigated many cases in recent memory in which women were treated in abusive or inhumane ways. Both the documentary and related news coverage reflected on these women's lack of rights and basic respect, and their lower status due to their gender. This caused me to stop and consider the changing roles of women in other parts of the world, especially in the United States, over the course of the last century.

I decided to focus my students to reflect on the past hundred years and the marked changes in the varied roles women play in world culture; specifically, how some women's ideals and accomplishments have paved the way for others to follow. These are individuals who refused to be limited by the constraints of family or society.

I think that now, in the first decade of the new millennium, we should take the time and opportunity to stop and reflect on the past hundred years. Who were the women who have made the most

5-9 Danielle Burgos
An ode to artist Frida Kahlo confronts the stereotypical roles of women.
Pen and ink, colored pencil, 18" x 24" (45.7 x 61 cm).

significant contributions to our world? How have they impacted and influenced culture and our future?

As we stop to appreciate where we have been and where we are headed, we can celebrate the future potential of both men and women.

Visual Problem

Students will create an image that celebrates a noteworthy woman or women of their choice, juxtaposing women's traditional roles with an expanded vision of those traditional roles.

5-10 Sean Keeton
This image uses humor to evoke the work of primatologist Jane Goodall.
Colored pencil, 18" x 24" (45.7 x 61 cm).

Student Choices
- composition
- choice of influential woman or women
- medium
- overall size and development of final image

Start-up Activity
Ask students: Who were the most remarkable or influential women of the past hundred or so years? For each woman identified, ask students to explain what contributions that person made that changed society's

Materials
▶ 18" x 24" newsprint
▶ No. 2 school pencil
▶ 18" x 24" white vellum
▶ pen and India ink
▶ a variety of drawing and painting media

Time
Twenty-two 45-minute periods: 3 for introduction and compositional sketches of a still life on newsprint paper, 7 for development of the pen-and-ink drawing, 1 for research in the library or media center, 10 for development of the final image, and 1 for evaluation and critique

perceptions and broadened the roles of women.

Create an ongoing list of the women whom students identify as significant. Have students ask their parents or guardians, grandparents, and other relatives whom they

Remarkable Women of the Last Hundred Years **113**

5-11 Rishi Roongta
Text that documents Amelia Earhart's achievements cover this well-crafted paper replica of her plane.
Pen and ink on paper, 5½" x 30" x 22" (14 x 76.2 x 55.9 cm).

would identify as significant women. Add these suggestions to the list of names. After a substantial list has been generated, add for each name a brief description of why the woman is noteworthy. *Ask students:* What positive effect did this individual have on society?

Ask students to differentiate between a person who is or was a celebrity and those who have truly influenced and made an impact. Have students reflect on this list and ask each to pick a person or persons they feel are or were particularly "gutsy" and who they feel made an impact on the future of women's roles.

Process
Part 1
To begin, create a still life that symbolically reflects the traditional roles of woman historically. Objects used might include irons and ironing boards, pots and pans, cooking utensils, clotheslines, men's white shirts, quilts, crochet doilies, canning jars, or mops and other cleaning utensils. The still life should include a generous amount of negative space.

Give each student a 18" x 24" sheet of newsprint paper. Have them fold the paper twice, creating four rectangles. Using pencil, students will create in each rectangle a compositional sketch of the still life.

Approximately twenty minutes will be spent on each section. Have students draw the still life from four different perspectives, focusing on spatial relationships while developing a strong composition. Students should be acutely aware of the

negative space, as it will serve as an important compositional area in the development of their final image.

Students then select the perspective chosen for one of these preliminary drawings as a starting point for creating a large line drawing (18" x 24") on white vellum. This is, once again, done by viewing the still life directly. Because this enlargement is four times the size of the original work on newsprint, it must be checked to ensure the enlargement is in proportion to the newsprint sketch. I suggest students first use the pink eraser end of a No. 2 school pencil to draw a few marks on the surface in order to indicate the correct enlargement before continuing with the pencil drawing. Students are asked to then draw lightly in pencil so that changes can be easily made.

This image is further developed into a finished drawing using pen and black India ink. Share examples of other artists' work that show a variety of ways that pen and ink can be used. These include hatching and crosshatching to increase the value of a given area, and the use of light and heavy marks for varied textural results.

It is important for students to realize that they can use this large black-and-white drawing as part of their final image focusing on an influential woman of the past hundred years. They might utilize the negative space for further development, or they might delete imagery for development of the area in another way. A new draw-

Praiseworthy Women of the Last Hundred Years: A Selection

Margaret Mead	Mother Teresa
Janet Reno	Billie Holiday
Amelia Earhart	Rosalind Franklin
Elizabeth Dole	Bessie Smith
Gloria Steinem	Frida Kahlo
Indira Gandhi	Georgia O'Keeffe
Betty Friedan	Margaret Thatcher
Golda Meir	Lillian Hellman
Helen Keller	Margaret Sanger
Rosa Parks	Sandra Day O'Connor
Annie Sullivan	Christa McAuliffe
Eva Perón	Madeleine Albright
Marie Curie	Eleanor Roosevelt
Marilyn Frye	Simone de Beauvoir
Hillary Clinton	Dorothea Lange
Clara Barton	Jane Goodall
Rachel Carson	Toni Morrison
Coretta Scott King	Zaha Hadid
Sally Ride	Margaret Bourke-White
Alice Walker	Shirley Chisholm
Maya Angelou	Jody Williams

ing using the traditional/stereotypical images of women's roles could also be developed for this process, for students who desire to keep the pen-and-ink image intact. This could be a three-dimensional structure or expressed in a paper relief.

Part 2

When the pen-and-ink drawing is complete, a class period is given to research in the school library or media center. Students understood that they would likely need to find additional nonclassroom time for research, but in the interest of this focused art activity only one class was designated for research.

Students were given a choice to focus on one significant woman or a combination of women. It was suggested that if students wanted to select more than one woman for their focus, they might think in terms of thematic qualities that would pull a group of individuals together. Students could think in terms of scientific, political, humanitarian, or artistic achievement. For example, a combination focusing on aviation and aerospace might include Amelia Earhart, Sally Ride, and Christa McAuliffe.

Students were reminded of the aim of the project, which was to create a composition juxtaposing

women's traditional roles with the accomplishment of a particular influential woman or women. As the students begin to work on developing the final image, the teacher becomes the facilitator, answering individual questions, providing a variety of artistic media, and encouraging thoughtful solutions to the visual problem.

During the studio working time for the pen-and-ink image, individual conferences were held to discuss the direction in which each student was headed, which woman or women a student selected, and how the student planned to develop the final image. This was time devoted to making sure students had a clear focus and were aimed in a positive direction.

The students were asked to write a short research paper, of at least 250 words, as homework, with one class period given to research in the media center.

The paper should begin with a clear thesis, explaining why students picked the person or persons they chose, and with specific information on the celebrated woman or women's contribution and an explanation of the subject's positive effect on society.

Students' final image should include a portrait or other clear reference to their chosen woman or women. As students developed this image, they were encouraged to think in terms of strong composition and to provide at least one clear area of emphasis that would draw the viewer into their work,

thus making it as striking as possible. Good craftsmanship in the use of materials was also a stated goal. A variety of drawing and painting materials were provided, and students were permitted to work in two or three dimensions, including relief.

Results and Observations

Working on newsprint for their initial sketch was an excellent way for students to consider varied compositions and think about what maintains visual interest on the two-dimensional picture plane. Developing four diverse preliminary line drawings also required students to walk around the room to develop perspectival views of the still life from varied angles.

Developing the pen-and-ink still life offered additional thinking time for the students to decide on the woman or women they wanted to select and for further research.

At one point in the process of developing the students' final image we met as a group so students could share their plans with one another. This was a motivation to greater risk taking and encouraged some students to be more inventive with their imagery.

For their research, students used the resources of the school's media center, including the Internet, and magazines such as a special edition of *People* ("Unforgettable Women of the Century") and *George* ("Twenty Most Fascinating Women in Politics").

Evaluation

Ask students to respond in reflective writing to the following questions: Has your project created a dynamic juxtaposition between the roles of women in the past and the individuals who have made significant contributions to changing those roles? Does your composition maintain visual interest that helps to focus the viewer on the woman or women you have selected? What do you hope the viewer will get from your image?

Conclusion

The success of this project depends on the combination of its elements. It begins with a clear structure of the visual problem, the cooperative gathering of information, the observational drawing, the written research, the presentation of a final creative image, and the reflective writing to understand what the student has gained through this experience.

This opportunity generated a great deal of increased knowledge for both the student and the teacher. The engaging images— images that went way beyond simple still life and gave insight into the important contributions of the women to society—drew the viewer to take a closer look.

Through the process the students reflected on key questions such as: "Should a person's potential be limited based on sex?" "How do some women feel empowered to take on new opportunities that will

5-12 Lila Symons
This image evokes the work of Rosalind Franklin, a Cambridge University scientist who made crucial contributions to the identification of DNA.
Pen and ink, colored pencil, 18" x 24" (45.7 x 61 cm).

inevitably break down gender stereotypes?" and "What can an individual do to make a contribution to our society today and in the future?"

We hope that as we ask our students to reflect on the accomplishments of others we will also be opening doors for them to contemplate their own potential. By looking at the impact that women have made on our society and by posing questions, we engage the minds of the individuals who will make a difference in the world of tomorrow.

The Soul of Japan: Cultural Iconography

Inspiration

A colleague in the history department and I, having both taken part in three-week educational experiences in Japan, decided to work collaboratively on this project, which was structured to increase our students' knowledge of the history, culture, art, geography, and religion of Japan. This studio would also fulfill our obligation to the Fulbright Memorial Fellowship to develop a series of follow-up experiences with our students.

In this experience, two senior honors history classes were asked to apply their knowledge of Japan in creating a work of art that explores the traditional iconography of Japanese culture. The visual format for the centerpiece of this collaborative project was a large wooden market umbrella that had seen many years of use on my patio at home. The recycled umbrella would provide the armature on which students would develop a mixed-media collage representing varied aspects of Japan. The images were researched, photocopied, drawn, and cut from magazines or Japanese newspapers.

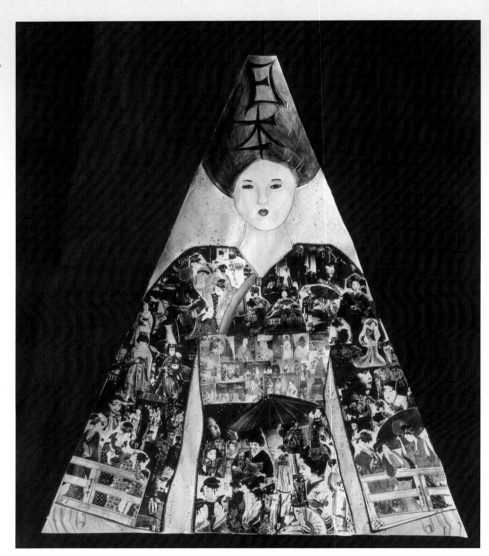

5–13 Erica Wraight
This student highlighted Japanese traditions as the essence of Japan.
Mixed media, 37" x 27" (94 x 68.6 cm).

Materials

▸ large wooden market umbrella
▸ large roll paper (100 lb. hard press)
▸ handmade rice paper or tissue paper
▸ recycled magazines, Japanese newspapers, images downloaded from the Internet
▸ colored pencils, markers, watercolor paints, black India ink, spray paint
▸ paintbrushes, scissors
▸ glue-water mixture
▸ masking tape and 10 lb. fishing line

Visual Problem

Students will work collaboratively to enrich their understanding of Japanese culture and to develop a mixed-media image that represents the essence of that culture. The structure of the artistic form to be developed is an umbrella.

Time

Eleven 45-minute periods: 1 for introduction, 3 for research/collecting collage materials, 5 to create image, 1 for mounting, 1 for reflective writing and critique

Student Choices

• subject area to be developed
• artistic media
• working alone or with another individual

Process

Students begin with a series of learning experiences in history class that furthered their knowledge about the people, history, arts, religion, architecture, geography, educational system, and culture of Japan. The art studio experience began with students using red spray paint to completely cover the panels of the market umbrella, thus creating a striking armature for the project's centerpiece. In developing images to be affixed to the armature, students were encouraged to

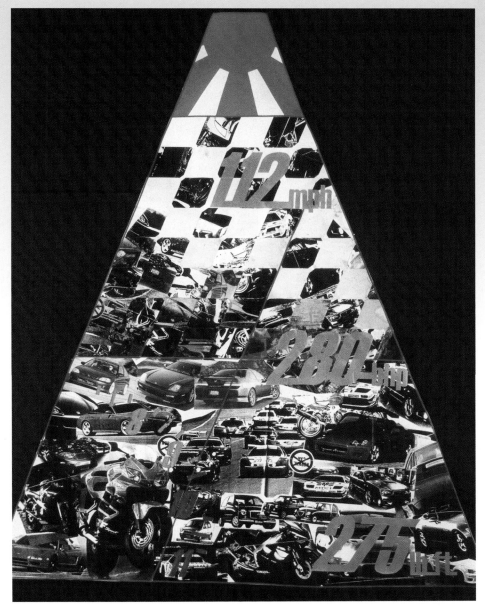

5-14 Mike Tomai
Mike's focus was on technology in the Japanese auto industry.
Mixed media, 37" x 27" (94 x 68.6 cm).

Houses without Walls

One cultural identifier of Japanese society is the umbrella. Historically, lighter skin was considered culturally desirable, and the Japanese people use umbrellas not only for protection from rain but also to prevent overexposure to the sun's rays. Umbrellas in Japan serve both practical and decorative functions and are often handmade, created using bamboo and rice paper.

In sharing a connection to art history, students were introduced to the work of conceptual artists Christo and Jeanne-Claude, specifically their project *The Umbrellas, Japan–USA, 1984–91*, which involved placing and simultaneously opening a series of 3,100 umbrellas across two valleys, one in Japan and one in California.

> The Umbrellas, *freestanding dynamic modules, reflected the availability of the land in each valley, creating an invitational inner space, as houses without walls, or temporary settlements and related to the ephemeral character of the work of art. In the precious and limited space of Japan* The Umbrellas *were positioned intimately, close together and sometimes following the geometry of the rice fields. In the luxuriant vegetation enriched by water year round,* The Umbrellas *were blue.**

All land on which the umbrellas were placed was eventually restored to its original state, and the umbrellas were taken apart and all elements recycled.

*www.christojeanneclaude.net/um.html

work thematically. Possible themes were: religion (Buddhism and Shintoism), landscape (maps, geography, volcanoes, Zen gardens), the arts (theater, dance, visual art, design and architecture), and people (fashion, politics, artistic design, historic clothing, etc.). The color scheme was limited to black, white, gold, and red. This was done to lend visual unity to the final work.

Japan is a country of contrasts, and many of the students thought about images that would address that issue, including comparisons between the past and present qualities found in Japan. Researched images could be photocopied or redrawn. Each student or group of two was given a sheet of white 100 lb. roll paper precut in a triangular shape, 37" x 37" x 27". (The market umbrella structure divides naturally into eight triangular parts, each individual shape starting at a width of approximately 2" closest to the pole and expanding to 27" wide at the outside edge. The length of each side is 37".)

Students were encouraged to arrange and rearrange their images to create a balanced composition with a discernible focal point. Images were applied to the white triangular paper using the glue-water mixture.

Students who chose to do so could use Japanese letter forms *(kanji)* as part of the design. Also, the names of the thematic area chosen could be translated from English to Japanese and used as a design element. This information could be researched through the knowledge of Japanese students or members of the larger community.

Students were instructed that the visual results would be evaluated based on thoughtfulness of approach to the visual content, artistic use of materials, effort in class, and the overall visual impact of the mixed-media image. They were also told that they would be given a series of reflective questions at the end of this process to verbally assess what they had learned.

Evaluation
Ask students: What aspect of this work was the most challenging? How did you overcome your difficulties? To what degree does your image create a visual essence of the Japanese culture? In what ways was your knowledge increased by this project?

Results and Observations
All students increased their understanding of the richness of another culture as they developed and produced their own mixed-media images and collages. One of the most significant problems was for the students to narrow the focus of

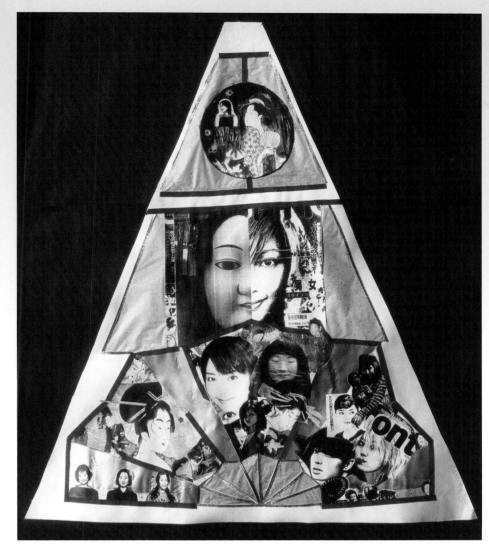

5-15 Courtney Dunn
There is a cultural dichotomy between main-
taining traditions and modern society.
Mixed media, 37" x 27" (94 x 68.6 cm).

In creating this project with non–art students, the focus was to increase each student's understanding of visual composition, collage process, and how to best use materials with the intent of maintaining the visual interest of the viewer. Our discussions on composition, use of focal points, and blending of varied materials was vital to the project's success. A number of students chose to work with a partner, which offered an added level of emotional comfort for them, resulting in a total of twenty-five images created. In the end, all of the students' final images were displayed in a large window space in the media center of the high school. Eight finished panels were chosen to be applied to the umbrella using 2" masking tape. The umbrella panels created a balance of alternating light and dark images, offering the viewer a quality of visual symmetry.

From the beginning, my intent was that all of the students be brought together in this exhibit. My vision, after selecting images for the main umbrella, would be to use the rest coming off this main structure.

The title of this striking exhibition was *The Soul of Japan.* The entire exhibit was suspended from the ceiling using coat hangers for the umbrella and fishing line for the individual triangles.

such a culturally rich country. Second was to develop a cohesive composition that maintained the viewer's attention. The color limitations of using black, white, gold, and red helped to add visual unity to the entire finished work. The results surprised the students, who from the beginning felt this process was going to be too challenging, yet they were all successful.

During the process the student enthusiasm was very high and many students chose to work after school in the art room or at home over the weekend. Only five class periods were designated for this mixed-media project. The student reflective writing indicated the depth in which they processed the quantity of the historical information and then in turn applied that to their specific area of interest to create their visual image.

Of the thirty-four honors history students who took part in this project, it turned out that only four had taken an art course in high school.

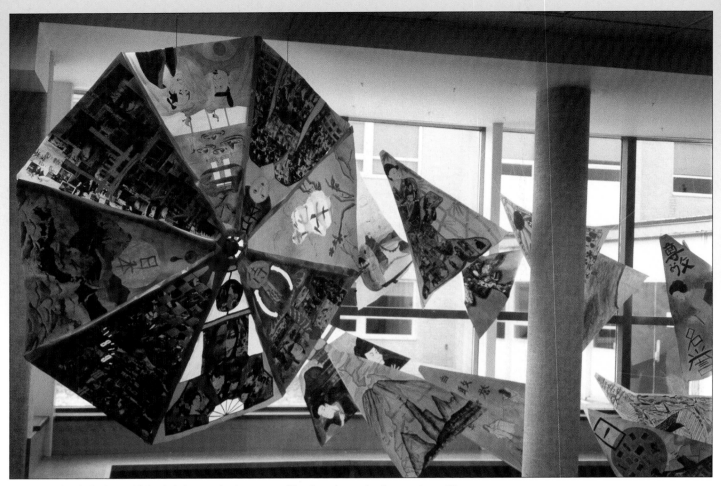

5-16 The final display exhibited eight panels that were affixed to the umbrella armature. All the additional student images were suspended with nylon thread and appeared to look like Japanese kites flying in the air.

Conclusion

Because I wanted all of the students' panels, not just the eight panels affixed to the umbrella, to be incorporated in the final exhibition, I envisioned that the umbrella would be the focus and that the other individual collages would somehow lead the viewer to that focus. The "ungrounded" panels could be seen symbolically as falling cherry blooms. In the end, one student reflected that they looked like Japanese kites flying through the air. The final work was certainly striking. The quality of the work created by non–art students was extraordinary and the use of airspace for this visual exhibition contributed to its dynamism.

Working with another colleague can be a very positive and powerful educational experience. In this case we both brought our expertise and enthusiasm to this project. Enthusiasm cannot be underestimated when venturing into new and unknown territory. Believing that your students are capable, and not losing sight of that, is important.

Student Reflective Statements

What aspect of this work was the most challenging? How did you overcome your difficulties?

"Perhaps the greatest challenge that I had to overcome was the aspect of capturing the essence of such a culturally deep nation on one small piece of paper."

—Shared Agarwal

"The most challenging aspect of this project was getting started and choosing which element of Japan I felt was the heart and soul of the country. For me, I was very interested in the architecture, landscape, and Zen aspects of Japanese life. It was difficult to fuse them together into an image that was 'the essence' of Japan."

—William Rohrbach

"The decisions about images and art materials created overwhelming feelings to try and plan our work, but we challenged ourselves and let our imaginations take over."

—Elizabeth Rzasa

To what degree does your image create a visual essence of the Japanese culture?

"The image captures the visual essence of Japan by its cultural and artistic simplicity and spirituality."

—Shared Agarwal

"There are so many things unique to Japanese culture that the essence of Japan doesn't have one right answer. The contrast of new and old is seen everywhere, and even that plays a part in Japan's essence."

—Lauren Thurlow

"I felt like I had to painstakingly design and create an image to be worthy of Japanese praise. Just trying to do that put me in the mind-set of what I would call 'Japanese thinking.' You have to think Japanese to create Japanese."

—William Rohrbach

"The piece shows what Japanese geography is like as well as conveys a sense of beauty to the viewer."

—David Hawryluk

"I was very excited when I finally decided what I thought the essence of Japan was. I felt it lay in its simple traditions that portray the honor and respect the Japanese people have for one another."

—Barbara Newman

"We feel the essence of the culture is captured in the visual, through representation of the uniqueness of the Japanese landscape."

—David Throckmorton and partner

"The essence of Japan depends on the beholder, to some it is the beautiful landscape, to others the religion. Each and every piece of this project is unique, proving how many different aspects of Japan are equally important and can equally convey the essence of Japan."

—Ali Whitehead

In what ways was your knowledge increased by this project?

"During the course of this project I have learned more about Japanese architecture. I have also learned that I can be more visually creative than I ever considered possible."

—Andrew Preston

"I had never realized the extreme contrast between traditional and modern influences on the people of Japan. I have grown to truly admire Japan after this project. [The Japanese people's] resilience over time is amazing."

—Jen Kling

"I increased my knowledge of Japan and about Japanese religions. I also learned a little bit more about myself from this project and that art should carry something more than physical beauty, such as a strong meaning."

—Shared Agarwal

"This project was extremely informative and beneficial to me in many ways. Besides learning a lot about art and the many different techniques that go into producing a work of art, which has a lot of research put into it, I also learned quite a bit about the country of Japan."

—David Throckmorton

"Not only was it relaxing to create artwork, but it was great to see what people in the class have put in their work. Everyone's ideas seemed to pull together nicely to create great images. I never expected so much from this project as we all have gained.

—David Hawryluk

Stick Puppets: A Community Service Project

Inspiration

Coordinated efforts between teachers can create excellent opportunities to broaden and diversify any art program. Art teachers can increase their value to their school community by offering suggestions for exploring ideas or themes through the creative use of media and materials.

This project was designed to support a new elementary school Spanish teacher who expressed the need to create visuals for a variety of basic Spanish words. The idea of making stick puppets evolved in response to my wish both to support the school's world language program and to offer a community service project for high school art students.

Visual Problem

Students will develop an articulated stick puppet that will offer a visual reference for teaching Spanish language to young children.

Time

Six 45-minute class periods: 1 to introduce the project, 4 to develop the puppet, 1 for critique

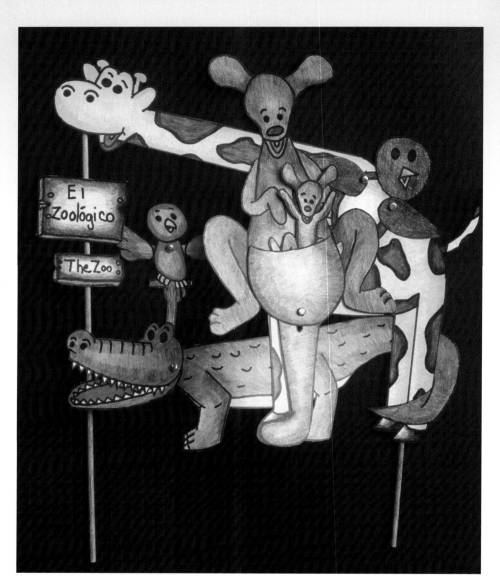

Student Choices

- overall size
- subject
- media
- use of one or two sticks

5-17 Jimmy Matejek
Entitled *The Zoo*, this work combines a number of moving parts in a very well constructed puppet.
Colored pencils, 18" x 18" (45.7 x 45.7 cm).

Materials
▶ oak tag board
▶ paper fasteners
▶ markers
▶ colored pencils
▶ pen and ink
▶ scissors and X-Acto knives
▶ white glue
▶ thin wooden dowels
▶ cellophane paper
▶ foam core board
▶ illustration board

Preactivity
To give my students a sense of the variety of artistic expression that might be explored through stick puppets, I shared examples of Indonesian stick puppets and shadow puppets.

Process
Students began by choosing from a list of words to develop as the subject of a stick puppet. The list of words, originally selected from the Spanish curriculum, was posted in both English and Spanish.

Students understood that their chosen subject would be defined using the language of art on one side of the stick puppet and the corresponding Spanish word or words on the reverse side. The stick puppets would offer visual examples for basic objects (nouns) and in some cases the connecting verbs. The art students were made aware that their puppets were for six- and seven-year-old students, so the work needed to be colorful, bold, and visually engaging.

Students were instructed that their puppets were to have at least four moving parts. I explained that the more articulated the movement, the more visually engaging the puppet would be. Holes in the varied oak tag shapes were created using a compass, and then the paper fastener was pushed through each shape. With the use of string, two or more parts could move at the same time. Students could also choose between using one or two sticks to support the main body and the moving parts.

Students could choose to use either oak tag or illustration board, along with paper fasteners and a variety of drawing media. The work

5-18 Dianna Wojcik
This graceful dancer suggests movement. Colored pencils, felt-tip marker, 22" x 8" (55.9 x 20.3 cm).

was to be well crafted and readable, since the young viewers would need to understand the subject and the translation on the reverse side.

Students were encouraged to thoughtfully develop the subject and think carefully about the complexity of the moving parts. They were encouraged to include a human or animal form in their stick puppet, if workable to their subject.

Evaluation
Ask students: Is the subject clear and visually readable? Is the puppet easily articulated to show movement? How well designed is the puppet for a six- and seven-year-old audience?

Results and Observations
The challenge in this project came from the need to design an idea for a particular audience and then developing that idea with moving parts. Students took great pride in their work and the opportunity to support the elementary Spanish program. One might think that creating stick puppets at the high school level would be too simple or elementary a project, but that was not the case. A number of students

5-19 Xun Li
The use of cartoon images produces a quality of light-heartedness.
Cut paper, 12" x 11"
(30.5 x 27.9 cm).

created innovative and striking designs.

Conclusion

As art educators, we can offer creative suggestions when asked by our colleagues, supporting their educational needs in fun and creative ways. This can also work to improve and motivate the adolescents we teach, while increasing their skills, personal expression, and sense of community involvement.

List of Terms for Students to Choose From

Animals

avestruz	ostrich
burro	donkey
caballo	horse
camello	camel
cerdo	pig
cocodrilo	crocodile
conejo	rabbit
delfin	dolphin
dinosaurio	dinosaur
ecanguro	kangaroo
gallo	rooster
gato	cat
gorilla	gorilla
hipopotamo	hippopotamus
leon	lion
leopardo	leopard
mono	monkey
murcielago	bat
oso	bear
panda	panda
pelicano	pelican
perro	dog
pinguino	penguin
tigre	tiger
gallina	chicken
jirafa	giraffe
rana	frog
vaca	cow
zebra	zebra

Relationships and People

familia	family
abuela	grandmother
abuelo	grandfather
mama	mother
papa	father
hermana	sister
hermano	brother
hija	daughter
hijo	son
amiga	female friend
amigo	male friend
maestra	female teacher
maestro	male teacher

Occupations

actor	actor
artista	artist
carpintero	carpenter
cocinero	chef
director de orquestra	conductor
pintor	painter
soldado	soldier
bailarina	ballerina
panadero	baker

Sports

baloncesto	basketball
beisbol	baseball
gymnasia	gymnastics

What You Don't Know . . . Health Issues

Inspiration

The beginning motivation for this project came with a gift of ninety new blue automobile seat belts—an unusual gift from a person who knew that art teachers love donations of free materials and are usually open to great visual challenges. The seat belts came in 5' lengths, without buckles.

My immediate thought was for students to create a series of posters dealing with automobile safety. After giving myself more thinking time, I decided to look at the seat belt as a broader metaphor for safety and protection. I would share the idea with fifty students in three classes, each of whom would then be asked to create individual works of art that would bring greater attention and awareness to the health issue of their choice. Students would eventually share this understanding with the larger school community, mounting an exhibition of their completed works.

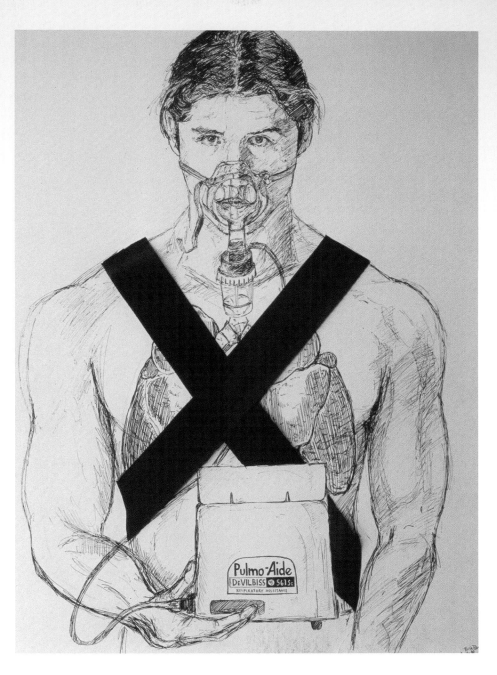

5-20 Taric Parvez
After a childhood of asthma, Taric chose to focus on keeping lungs healthy.
Pen and ink, 24" x 18" (61 x 45.7 cm).

Visual Problem

Using nylon seat belts, and any other devices symbolic of protection, students will create a striking image that relates to a current health issue that they feel is significant. The image will serve as an object of advocacy for the prevention of a specific illness or injury.

Time

Fifteen 45-minute periods (in addition to 3 weeks' out-of-class research time): 3 for introduction, discussion, and presentation of research topics, 10 to develop image, 1 for critique and sharing of reflective writing, 1 for installation of exhibition

Student Choices

- subject
- overall size
- working in two or three dimensions
- media

Start-up Activity

I began by leading a discussion with each group of students about how people can protect themselves in healthy ways, and we brain-

Materials

- nylon seat belts and any other devices symbolic of protection
- 16" x 20" illustration board
- a variety of drawing and painting media
- a variety of mixed media: embroidery thread, needles, wire, foam core, etc.

List of Personal Protections Discussed

Health Issue	Protection
AIDS	avoidance of IV drug use and unprotected sexual contact
auto accident	not driving drunk or allowing others to do so
auto injury	wearing seat belts
breast cancer	regular examinations and mammograms
child abuse	education, counseling, community mental health support
fire injury	use of smoke detectors, education
gun violence	safety education and gun control
head injury	wearing of helmets for sports such as bike and horseback riding, skiing, skateboarding, and in-line skating
heart disease	genetic awareness, diet, exercise, etc.
liver damage	avoidance/moderate use of alcohol
lung cancer	avoidance of smoking
obesity	diet, education
skin cancer	use of sunblock, minimized exposure to sun's rays
testicle cancer	self-examination
unsafe products	community awareness
unwanted pregnancy	birth control, abstinence, use of condoms
vision loss due to ultraviolet rays	wearing sunglasses
work-related hearing loss	use of earplugs

stormed a list of health-related topics.

Each student was asked to select one issue that he or she felt particularly strongly about or wanted to learn more about. Students were given the task of researching and gathering information on that topic, for later presentation to the class and application in their studio project.

The title of student research would be: "What you don't know . . ." To stimulate their

thinking, I provided students with the following examples:

What you don't know is . . . "Smoking causes 80 percent of all cases of lung cancer."

What you don't know is . . . "First-time offenders caught driving drunk in the state of New Jersey will pay $3,500 in legal fees and automatically lose their license."

What you don't know is . . . "As of June of 1998, 401,028 people had died of AIDS in America."

5-21 Jessica Ausen
This is a powerful tribute to a father who died due to alcohol abuse. The seat belt is used to frame the image.
Mixed media, 24" x 18" (61 x 45.7 cm).

What you don't know is . . . " Every 11 seconds, a teen in the United States is exposed to a sexually transmitted disease."

Students researched their chosen health topic through current periodicals, books, and on the Internet. All sources, including Web sites used, were to be documented. In addition, students were encouraged to contact local heath officials, family doctors, school nurses, or other professionals to help locate information on their chosen issue. Three weeks' out-of-class time was allotted for gathering information before the second group discussion.

Process
Students spent the out-of-class time in three ways: on research and beginning thinking about what form the project would take, including thinking about how the image will "read," and planning for acquisition of any unique materials necessary to bring the idea to fruition.

The introductory-research phase complete, I asked students to verbally share their findings by composing three "What you don't know is . . ." statements that could be used to increase awareness of their chosen heath issue. I posted this typed research on large display panels for the three different art classes to read, and it was also included in the exhibition of the final visual work.

Each student was provided with one nylon seat belt for integration into their visual image. Students were allowed to work in any media or mixed media, on any scale, and in either two or three dimensions. Strong, dynamic images were encouraged. A few words might be added to the visual image, if the student felt it necessary.

Throughout this studio experience, I worked as a facilitator to answer technical and material concerns, validate student thinking, and offer support as projects were developed.

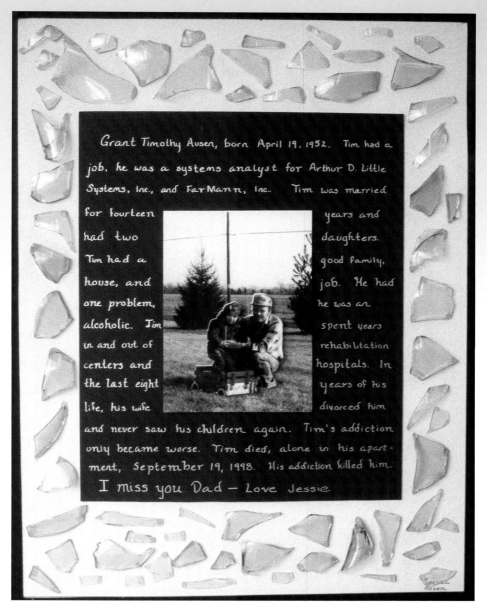

Grant Timothy Ausen, born April 19, 1952. Tim had a job. he was a systems analyst for Arthur D. Little Systems, Inc., and FarMann, Inc. Tim was married for fourteen years and had two daughters. Tim had a good family, house, and job. He had one problem, he was an alcoholic. Tim spent years in and out of rehabilitation centers and hospitals. In the last eight years of his life, his wife divorced him and never saw his children again. Tim's addiction only became worse. Tim died, alone in his apartment, September 19, 1998. His addiction killed him.
I miss you Dad — Love Jessie

Artists as Advocates

As part of the start-up process, I shared art-historical examples of works that have served to bring greater attention to social or political issues. For example, artworks by Kathe Köllwitz that show mothers protecting their children from the ravages of war. Or Piccaso's *Guernica* (1937), which evokes the idea of protection from the human destruction wrought by fascism.

Evaluation

Ask students: Why did you pick the subject you selected? How has your knowledge of health-related issues increased? What are some of the elements that create a striking image—one that draws the viewer into the work? How do you hope others will be affected by your 'protection' image?

Results and Observations

The beginning discussion on health and protection issues was done before my students even knew they were going to be given a seat belt as a jumping-off point. This got them thinking and set the stage for this very creative challenge.

During the research process, I gathered current newspaper or magazine statistics on various health topics to share in the classroom. This served as a reminder of where the project was headed and also drove home the fact that our human health is of daily concern.

As students came up with creative ideas, they were allowed the time to share them with the entire group. This served as a motivation for developing varied solutions to the visual problem.

The work, both two- and three-dimensional, was gathered in the high school media center. An explanation of the project, and the students' "What you don't know is . . ." statements were also shared on large exhibition panels, showing the

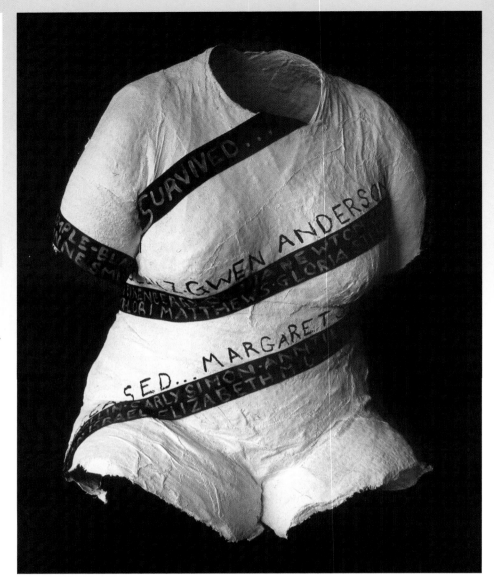

5-22 Sarah Sheber
After a family member was diagnosed with breast cancer, Sarah set out to heighten other people's awareness of the need for screening and early detection.
Plaster cast, acrylic, 24" x 14" x 11" (61 x 35.6 x 27.9 cm).

depth of the students' new knowledge. Each individual project was accompanied by a brief reflective statement for the viewer's benefit in gaining further insight into the subject.

After the exhibition, a compilation of the student research produced for this studio was given to the health teachers for their own possible classroom use.

Conclusion

Psychologically, adolescents are beginning to think about their own mortality and yet do not want to reject the idea that they are invincible. Added to both the physical and psychological changes in their development is an expanding worldview. As a result of this they become aware of many issues that can affect society as well as themselves, their family, and their friends.

It is hard to gauge the influence of this type of learning and expression on the students or the larger community that viewed the exhibition, yet I feel the impact can be far reaching. The visual problem at the beginning of this project grew out of my desire to raise students' consciousness about health issues. Eventually, it led to group learning in which all of us expanded our knowledge even more than we might have expected to. The students' visual expressions, shared with the larger community, in turn created greater learning and awareness.

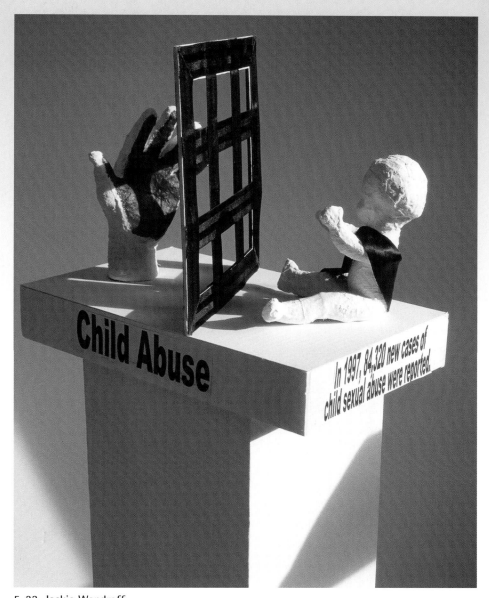

5-23 Jackie Wendroff
This piece speaks out against child abuse for those who do not have a voice of their own. Mixed media, 18" x 19" x 12" (45.7 x 48.3 x 30.5 cm).

Inside Outside: Values, Character, and Stereotyping

Inspiration

Over a span of two years, a number of ideas overlapped to focus the concept explored in this project. In considering the concepts of values, character, and role stereotyping in our culture, I wanted to design a studio experience that would help my students better understand their personal values while also considering what goes into building character.

A strong early influence for this project was provided by my visit to the Cambridge Contemporary Art Gallery in Cambridge, England, where an artist by the name of Ellen Bell was exhibiting a number of articles of clothing made from paper. One image in particular caught my eye, a formal woman's dress, entitled Wedding Bands, *created using antique wedding documents. This image spoke of how, historically, a married woman was bound legally and morally by the wedding vow into what Bell's piece strongly suggested was a restricting condition.*

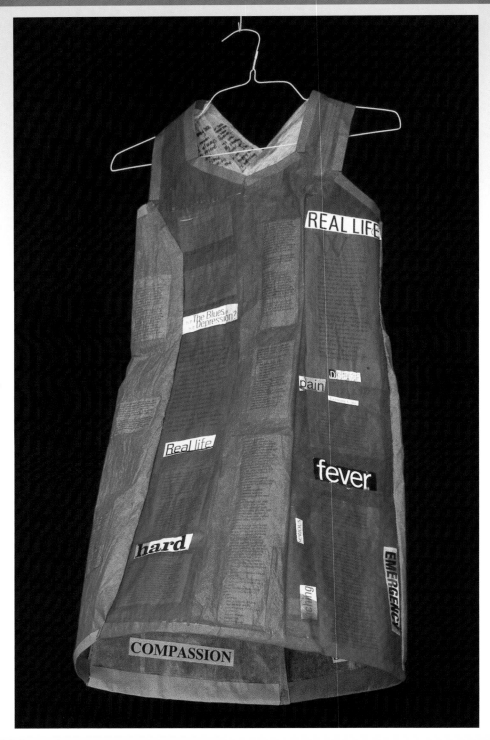

5-24 Ellie Gluck
Mixed media, 5' x 18" x 11"
(60 x 45.7 x 27.9 cm).

In further researching the topic of clothing I came across a few magazine articles that viewed clothing in contemporary ways, including a piece on the innovative Japanese designer Issey Miyake. These articles suggest that fashion can move into the realm of art as it provokes thinking and reaction and as it gives us a vision of contemporary culture.

I eventually determined to combine an inquiry into character issues and clothing.

Visual Problem

Students will create a three-dimensional, life-size article of clothing using varied kinds of paper. This article of clothing will use text and imagery to explore shared values, character issues, and/or gender stereotypes that we as humans have assimilated through our culture.

Preactivity

Before introducing this studio to the class, I gathered numerous images from the magazines I'd referenced for mounting and display on poster

Materials
▶ brown and white roll paper (36" width)
▶ rice paper
▶ tracing paper
▶ magazines, newspapers
▶ scissors, X-Acto knives
▶ white glue,
▶ masking tape
▶ staples
▶ needle and thread

board. I also shared images of Ellen Bell's work, as I wanted students to be conscious of this contemporary art-world reference as the proceeded with their own inquiries.

Start-up Activity

I began by leading a discussion on how clothing can be seen on varied levels either as practical or as adornment. From an artist's perspective, clothing can be viewed as an object of fashion design as well as a 3-D sculptural form. My students talked about how text is now seen on the clothing that many people wear today, and not just T-shirts. In many ways, we have become a

Student-Generated List of Desirable Personal Traits

decency	dependability
fairness	trustworthiness
empathy	dedication
self-sacrifice	caring/empathy
loyalty	citizenship
duty	cooperation
service	integrity
honesty	sportsmanship
honor	independence
respect	responsibility

5-25 Arielle Ginsberg
Mixed media 12" x 17" x 10" (30.5 x 43.2 x 25.4 cm).

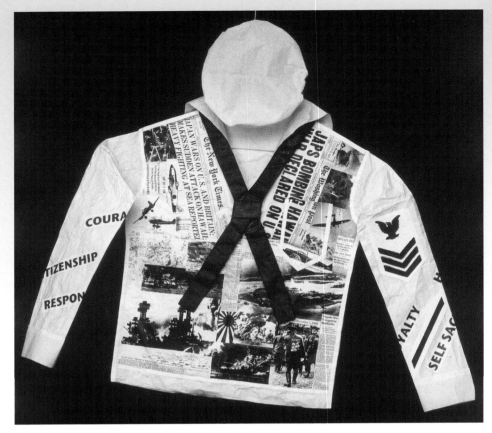

5-26 Rishi Roongta
Mixed media, 31" x 20" x 4"
(78.7 x 50.8 x 10.2 cm).

culture that has turned into walking advertisements for clothing companies. We are now seeing clothing forms and text blending as a social value.

As I steered the discussion toward a focus on personal character, students were asked to brainstorm various qualities that go into shaping character. The students developed a list of words signifying positive qualities, as well as their definitions.

Process

After I introduced the visual problem, I provided an example to help the students see the possibilities for the paper clothing project. They were asked to envision a fireman's jacket or a fireman's hat, actual shape and size, made out of newspaper images of New York City before, during, and after the attacks of September 11, 2001. By viewing the destruction of the World Trade Center in relationship to a fireman's uniform, a viewer might see the powerful connection between the occupation suggested by the uniform and the personal values suggested by the images decorating the uniform. This imagined image suggests character issues such as self-sacrifice, duty, service, honor, citizenship, and responsibility.

Students were asked to consider using both the inside and the outside of their created garment. One suggestion was that perhaps the outside could represent the stereotypes of a given character trait, and the inside the actual realities. Students were asked to consider different kinds of uniforms worn by members of the military uniforms and by doctors, rescue workers, superheroes, and sports figures, and how these forms of dress carry social and sometimes political overtones. Students were asked, to think about how such stereotypes might be broken down and addressed in their projects.

Craftsmanship in the final image was important. It was understood that all materials used to join or support should be invisible to the viewer, so students were instructed to avoid using visible adhesives such as tape, staples and glue. Only thread, if used, would be acceptable.

Student Choices
• subject
• type of paper
• use of color

Evaluation
Ask students: In what ways does your project express the inside and outside of the issues you think are important? What makes your visual image engaging? How well is it crafted? How has your understanding our cultural influences increased? What have you learned through this process?

Student Reflective Statements

Lena Potechin

Oil spills continue to be a treat to nature, and in 1989 when the Exxon Valdez crashed at Prince William Sound, thousands of people came to aid in the cleanup. I chose to create the boots which the cleanup crew wore to depict the struggle for an environmentally safe world. I hope by doing this project I'll inform people about the dangers that still exist in crude oil transportation.

Jill Vanzino

I chose the subject of women's rights and insecurities. I decided on a corset because to me it represents insecurities of women, what they seem to be on the outside and what they really feel on the inside. I hope that from this project people, especially men, will get some insight into what it feels like to be a woman in the twenty-first century.

David Jou

Since sports is such a big part of my life I thought I would make some type of uniform or jersey relating to sports. I chose to make a referee's uniform because it symbolizes fairness and a sense of responsibility which is important not only in sports but also in life. The black and white and the way the words were added in the stripes also shows organization, duty, and authority.

Erin Santye

The reason I chose my issue, growing up, is because it is an issue that many teenagers, particularly girls, deal with. Personally, its hard to imagine myself growing up, but it's even harder for my parents to imagine it. They don't see their "little girl" as a woman quite yet. There are many different aspects of being a girl and being a woman. I chose these pieces of clothing because they are very feminine. I hope adults in particular come away with the awareness that the future does come and children do grow up.

Ellie Gluck

I did this project because I have a personal experience with the subject matter. Crohn's disease has been a big part of my life since I was nine. While I was doing this project, I learned that I am not the only one who has gone through the same experiences. When I first started this project, I had hoped that it would be a jumping off point for others to understand this life altering, but manageable disease. From far away, you can see that the dress is very beautiful and shows a lot of color. But when you look at the exterior very closely, you can read all this informative text about the basic knowledge of Crohn's disease. When you look inside, you can see that the text that makes up the interior is a diary of my own personal experiences.

Arielle Ginsberg

I wanted this project to make people more aware of the world around them. I wanted to express the strength of the people, mostly Muslim women and girls, who have suffered in the Bosnian rape camps. While doing the research for this project I realized I want to go to college and major in political science to advocate for human rights.

The writing seen on this piece consists of excerpts from BBC World News articles about the rape camps as well as quotes from Bosnian women and their experiences throughout the war.

Rishi Roongta

I chose Pearl Harbor because it was an event of major importance to America and WW2. We lost many lives and many innocent people, who should all be remembered. My piece captures the horrific images of Pearl Harbor from both sides, the Japanese and Americans. These images are put together as a collage on the outside of the white navy uniform. Words of positive character qualities of the sailors, officers, nurses, and other people involved in war, such as duty, honor, courage, self-sacrifice and more are placed around the sleeves. Pearl Harbor will never be forgotten.

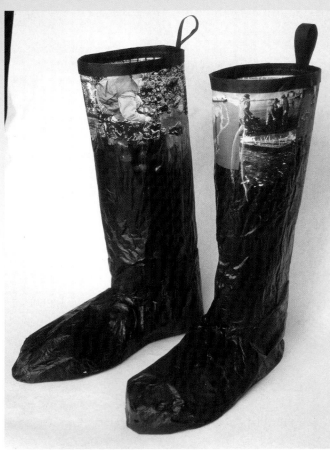

5-27 Lena Potechin
Mixed media,
16" x 5" x 12"
(40.6 x 12.7 x 30.5 cm).

Some students began by making small paper models before working larger. Most, after deciding on their subject, worked life size. Also available to students was some thin natural reed, commonly used in basket weaving, to add support to the inside of their article of clothing.

Storage is always an issue with large projects, yet a simple solution quickly came to mind. Students' paper clothing was placed on metal clothes hangers and hung from the

Results and Observations

Students first needed time to brainstorm ideas, then choose one in which to focus, followed by research to acquire the necessary visual information before actually beginning. Discussions happened, on a daily basis, first with the group and then one on one, regarding what ideas would work best and why. As usual first ideas often led to more meaningful approaches. Three or four days were spent thinking, discussing, and researching information for the individuals projects.

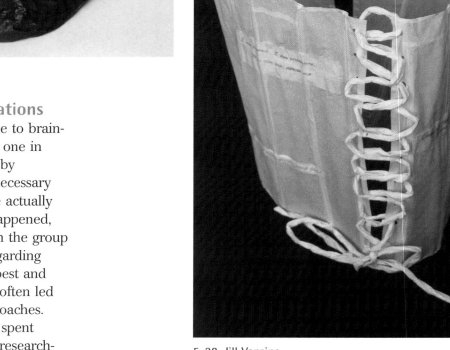

5-28 Jill Vanzino
Mixed media, 13" x 10" x 9" (33 x 25.4 x 22.9 cm).

5-29 Ellie Gluck
The interior of Ellie's work reflects the hope, courage, and determination required to manage a life-altering disease.
Mixed media, 5' x 18" x 11"
(60 x 45.7 x 27.9 cm).

art room ceiling's acoustical panels. This kept the work off the table surfaces when students were not working on this project.

Time
Fifteen 45-minute periods: 1 for introduction, 13 to develop image, 1 for critique

Conclusion
Visual artists often focus on addressing societal issues, using a variety of media for their personal expression. By limiting the media for this 3-D project to various kinds of paper, the students focused on the sculptural qualities of clothing in the context of their chosen subject matter. By looking beyond clothing as simple adornment or fashion, students came to understand that it could have impact as an artistic statement developed with thoughtful content.

Conclusion

I believe that the arts are essential to supporting the human spirit. Historically, our culture has not done enough to celebrate the arts. As artist-teachers, we need to be positive role models to enthusiastically support students and each other in the field. Participation in my state's art education association, as well as the National Art Education Association, has given me some of that support to which I am referring. No journey is too difficult when you have the support of other professionals, whether other art teachers or colleagues in other disciplines. One thing that is truly needed in our schools for promotion of art and arts learning is the support of the academic administration. When principals and academic administrators acknowledge and support the work of art teachers, they validate the art-learning process and fuel its success.

What is it, exactly, that influences the artist-teacher's staying power? For me it is and has been having a personal vision, which has evolved over time. Through great administrations and not so great, through teaching on varied levels, and in a number of different environments, it is the vision of what kind of teacher I wanted to be: a teacher with a drive to continue to learn, to develop and refine art-thinking and communication skills, to increase student empowerment, risk taking, resourcefulness, and reflective thinking. These qualities have all contributed to shaping my personal vision and my teaching philosophy.

I am a firm believer that if you can surprise yourself you will surprise others. As we continue to grow and to explore new ideas, we can create ripples, like those from a pebble dropped in a still pond, until we have achieved beyond all ordinary expectation. As teacher and astronaut Christa McAuliffe said, "I touch the future, I teach."

In conclusion I would like to say:

Remember your focus in teaching. It is all about the quality of your work as an artist-teacher, improving your skills, your knowledge, your ability to communicate and to promote student growth in learning.

Keep the artist inside alive.
Be a dreamer.
Be a visionary in your work.
And be passionate about your
 vision.
Be *extraordinary!*